I0135041

INTO THE CANYON:

LIVING WITH FIBROMYALGIA
RX FREE

R. Eileen Moore

The contents of this book are not intended as medical advice or as a reckless endorsement of risk-taking. Each person must weigh his or her abilities, his or physical limitations and their own safety before they make any decision in life. This story is intended to encourage those who live with pain to live life to the brim and running over. We recommend that each person consult his or her doctor before making any decisions regarding their health and well-being.

Morten Moore Publishing and the author are not liable for any harm or damage to persons who may choose to follow the decisions that the author implemented in her own life. We encourage others to think, to fully examine their decisions before choosing a path that may bring risk and physical harm to the body and mind.

Published by Morten Moore Publishing, 2020
All rights reserved to Ruth Mortenson
Copyright May 2016
ISBN 978-0-9991108-5-0

Morten Moore Publishing
PO Box 881
Flagstaff, Az 86002

Living with Fibromyalgia Rx Free

Choices

We all have choices in life. Some choices bring us good, others we may live to regret. When we are young, we often ignore the idea that our choices will bring consequences that are either welcome or potentially disastrous.

Currently, many doctors seem to believe that prescription drugs are the best treatment for fibromyalgia. Like other patients with fibromyalgia, I didn't want to take a prescription drug for this condition and began looking for other options.

Making choices about how we live is one way of treating the symptoms of fibromyalgia. This may not be affective for everyone. Some patients may choose to combine drug therapy with many of the ideas that we will explore using an integrative approach. Regardless, I don't want anyone to believe that drugs are the only solution to the challenge of living with fibromyalgia.

In 2010, I hiked across the Grand Canyon and in those three days was born this discussion of living with fibromyalgia prescription free.

There is a choice.

Thinking Beyond the Rim

On September 19, 2010, I walked the last few steps to the Grand Canyon's south rim and leaned against an iron railing for a quick photo. I had just hiked twenty-four miles from the north rim to the south rim of the Grand Canyon.

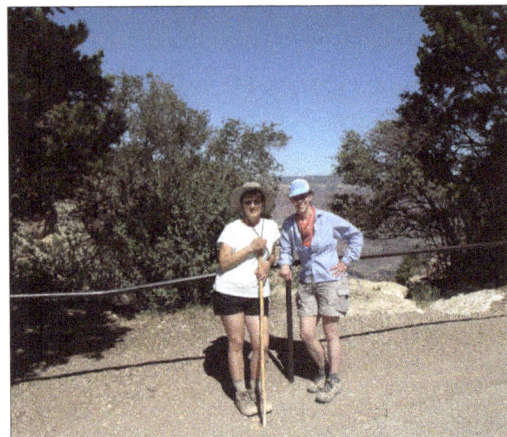

I was diagnosed with fibromyalgia in May, 1990. Other than ibuprofen and acetaminophin, I do not take Lyrica, anti-depressants or any other prescribed drug for this condition. Instead I rely on lifestyle management. So many people, when they learn that I have fibromyalgia, tell me they have a friend or relative who has been diagnosed with the condition and lives in terrible pain.

"How do you deal with this?" they ask. "Got any tips you can pass on?"

"I don't take prescription drugs," I tell them. "I prefer to use lifestyle management. Do you understand what that means?"

We talk about balancing proper rest, non-impact exercise, diet and mental conditioning. I suggest a combination of supplements and the judicious use of heat or ice. I suggest that acetominophen or ibuprofen may help, depending on the type of pain their friend is experiencing. I also talk about the role of attitude in adjusting to a new condition. If time allows, I admit to a strong desire to persevere against pain and a belief in God's goodness.

There are times when the pain gets to be too much. I rarely talk about the times I have ended up in a fetal position, trying to breathe as lightly as possible. Instead, I encourage others to believe that if they hang in there, they will see an improvement. Ninety percent my time, I live all out, enjoying the activities I'm involved in.

To those who know a person with fibromyalgia, I simply say: Encourage your family member or friend to tackle this condition head on. Encourage them not to allow the pain and fatigue to defeat them.

I love being outdoors, whether working in my yard or hiking along a beautiful trail, but fibromyalgia has made outdoor activities more challenging. In the 1990s, as I was raising my children, I decided to write a book about hiking, detailing many of Arizona's best trails for children. There were times when the pain was so debilitating, I rocked back and forth like a penguin as I tried to walk. At that time, I thought the distance and effort in hiking the Grand Canyon was be beyond my abilities and physical strength.

The Canyon remained, taunting me. I could almost hear the echo, "You love hiking but you haven't hiked my trails yet."

I had hiked the trail into Havasupai, a side canyon to the Grand, most recently in 2006, with five other women. We had a great time, although I struggled to climb the last two miles of switchbacks to the trailhead. I considered Havasupai to be different than the harsh trails of the central Canyon: Bright Angel and Kaibab, Grandview, Hermit, the Tonto, just to name a few. Veterans of the Canyon talk of heat and blisters, carrying precious water, the sun beating down, draining one's strength. They speak of the beauty that surrounded them - in a desert.

One day, I looked at a hiking partner and said, "I made it out of Havasupai. If I'm ever going to do the Canyon, this has to be the year." I was 56 years old and had lived with fibromyalgia for 20 years.

"Do you mean that?" she asked.

"Yes!" We sat looking at each other, considering the possibilities. She recognized my determination to complete such a demanding trek.

"Then, I'm coming with you," she said. "When do we start training?"

The idea of hiking rim to rim within the Grand Canyon sounded like a great idea, except,
I had fibromyalgia.
Thoughts of being stranded deep in the depths, unable to walk out, floated through my brain. What if I was injured from carrying a heavy pack? Would I be able to actually handle three days of hiking, carrying a heavy pack?

4

Talking Grand

Basic Facts

The Colorado River sweeps south from Utah into Arizona, through Marble Canyon, before turning west en route to Lake Mead. Along 277 miles, the Canyon averages a mile in depth and at its widest point is ten miles across from rim to rim. Grand Canyon Village on the South Rim is the most frequently visited locale on the Canyon's rim and is the site for several of the Canyon's southern trailheads.

Across the Canyon on the North Rim is a small community offering amenities to visitors. This is the closest outpost to the North Rim railhead for hikers choosing to either descend to Roaring Springs or hike cross-canyon. Between these two points, the only sign of civilization or habitation is Phantom Ranch. No trailside snack bars, no restaurants or hotels. No first aid stations. No private homes, just open, exposed, harsh wilderness.

The most popular route for cross canyon hikers is a combination of the North Kaibab Trail with either the Bright Angel or South Kaibab Trails. Depending on the route, the distance by foot is twenty-two to twenty-four miles, passing through Phantom Ranch. Hikers looking for a different route may choose some other combination, utilizing the Tonto Trail that intersects other trails descending from the rim.

The North Rim's elevation stands at 8,000 feet above sea level, the South Rim at 7,000 feet. Many hikers choose to descend either through Indian Gardens by either the Bright Angel trail or the South Kaibab trail to the bottom of the Canyon. Many stop at Phantom Ranch overnight before ascending the North Kaibab trail, with a break at Cottonwood Campground, climbing an extra 1,000 feet in elevation. Others prefer hiking north to south to avoid climbing the extra 1,000 feet. Then, there are the extreme athletes who prefer to run rim to rim and back again in one day. Along the route, it is not uncommon to move to the side as the runners jog past.

While both the North and South Rim will see snow in mid winter, summer temperatures may climb as high as 130 degrees in the depths of the Canyon. During the winter, temperatures remain moderate at Phantom Ranch while the trails just below the rim may become ice-packed from steady foot traffic. The road to the North Rim is closed from mid October to mid May.

To even the healthiest person who has trained for months, hiking across the Grand Canyon can be a serious challenge. To someone caught in the pain and the struggle of fibromyalgia, the idea of hiking 24 miles across a deep canyon and climbing thousands of feet in elevation seemed overwhelming.

How does a person with fibromyalgia attempt a difficult challenge like a 24-mile hike through the harsh terrain of the Grand Canyon when simply living can be challenging?

As I write about the challenges those with fibromyalgia face, whether with everyday living or a serious physical endeavor, I understand that an extreme physical effort like hiking the Grand Canyon is not for everyone. We each have an endeavor that we would like to achieve in life. Setting an attainable goal can be motivating. This is what the Grand Canyon became for me.

What is your goal? We share common ground in living with fibromyalgia. While you may have a different goal than hiking the Grand Canyon, the challenges we both face are kin. As you read the following pages, let's walk together in the pursuit of wellness. Let's step up to the challenge of living well.

Living with Pain and Stiffness

Men and women who first encounter the pain of fibromyalgia that creeps through their joints and across the surface of their skin make an appointment with their primary care doctor. After test results come back, some doctors suggest the patient needs to relax a little and see a counselor for help since nothing showed up on the test results.

Don't cry or get angry! Thank the doctor and make an appointment with a rheumatologist! He or she knows the symptoms of fibromyalgia and can help with a diagnosis.*

The Mayo Clinic describes fibromyalgia (FMS) as "a disorder characterized by widespread musculoskeletal pain accompanied by fatigue, sleep, memory and mood issues." The Clinic further describes this condition as a miscommunication between the nerves in the body and the brain.

The primary symptoms of fibromyalgia include chronic nerve tenderness, musculoskeletal pain and stiffness. Along with the pain comes

*Not all rheumatologists know what to do with fibromyalgia. One experienced with the condition will direct you to the right resources. Canada's health system does not allow rheumatologists to treat those with FMS.

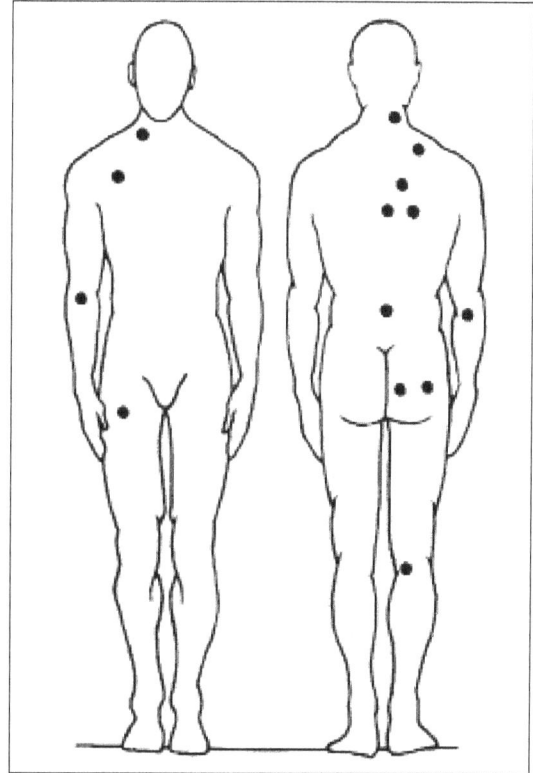

This image taken from the Arthritis Foundation pamplet on Fibrositis shows the trigger points where pain from fibromyalgia may be active. The pain may occur on either side of the body, lasting from a few minutes to years.

fatigue and challenges in cognitive thinking.

The pain may be sharp and easy to pin point or it may present as a burning sensation spread over the surface of the skin. Years ago, the conditon was known as Old-Fashion Pain Syndrome. This condition can live up to the name!

The pamphlet on fibromyalgia distributed by the Arthritis Foundation, has a chart indicating the location of trigger points producing pain in the human body. A rheumatologist may put pressure on these points, watching your reaction. If you have pain in eleven of eighteen specific locations on the body, the doctor may diagnose fibromyalgia.

Unfortunately, fibromyalgia, with its broad variety of symptoms, has the ability to mimic other conditions. The usual tests often show inconclusive results. Fibromyalgia cannot be diagnosed with a blood test.

Along with the pain, fatigue can present as either a lack of energy to rise and perform the tasks of daily living or it can reside deep in the muscles. The latter may feel as one who has just run a long race with their mucles aching. As if they lack the energy to lift a leg or arm. Fatigue may be so deep that you have trouble getting out of bed or moving around their homes.

Cognitive difficulty may present like a fog moving though our brains. Those with this condition struggle to organize thoughts, set goals and judge their progress.

Living with Fibromyalgia is not hopeless! You have a choice!

Along with pain, fatigue and cognitive challenges, fibromyalgia may include anxiety, depression, heart palpitations, gastrointestinal disturbances, headaches with sensitvity to light, sound and smells and sleep disturbances.

One popular commercial describes fibromyalgia as a nervous system on steroids. If that sounds extreme, consider this encouraging throught: fibromyalgia is not progressive. The condition does not get progressively worse as time passes. However, the condition is cyclical with ups and downs depending on a number of factors. Each person is unique and may exhibit different symptoms which change with the season and

environment.

As if the physical struggle is not enough, a doctor may refer a patient with fibromyalgia to a psychiatrist. Friends and family, failing to understand the condition, may encourage the patient to 'just do better.' The implication that 'this is all in the mind' may chip away at the patient's sense of well being, causing the person to question their value as they confront this challenging condition.

For me, the day my rheumatologist diagnosed fibromyalgia was a relief. I finally learned the source of my pain, fatigue and sleep issues. He had a plan to treat the condition, which included a prescription for Amitriphyline, an anti-depressant, which helped stabilize my sleep patterns and reduced the pain. He did not tell me I needed to seek psychiatric help. I was excited to move forward. Over the next month my life returned to a normal routine.

Then our summer rains moved into the southwest. Pain viciously attacked once again. I wondered what had happened to that sense of euphoria. The doctor assured me that this was a common response to the barometric pressure

Mental Soundness

Many fibromyalgia patients have been told that their symptoms are all in their head. When I was first diagnosed with fibromyalgia, my doctor remarked, "You just need to get counseling and you'll be fine."

I did not appreciate a doctor telling me that I needed counseling. I mentioned his comment to a physical therapist and she agreed that I might need counseling. Before I could react, she added, "Don't think of it as being really screwed up. Think of counseling as helping you to focus on what is important."

I'm in favor of focusing on what is important. With that perspective, counseling didn't seem like such a threatening idea. I could learn to set aside the negative influences and painful memories from the past, moving toward a healthier frame of mind. Finding the right counselor to help us is important and the right counselor may not be someone who has a counseling degree. That person may just be a good listener who asks the right questions and helps you move in the right direction.

dropping. He raised the dosage of the anti-depressant.

My body quickly became dependent on Amitriphyline to regulate my sleep patterns. I did not realize that in the process, I was becoming increasingly irritable with my family and others around me. Irritability is one of the side effects of this anti-depressant. When taking a drug, people should be aware of the side-effects of the drug and consider whether the benefit from the drug is worth the effect on the person and their family.

In recent years, Lyrica has been introduced as a drug to treat fibromyalgia. Like all drugs, Lyrica has side effects. Whatever drug they choose, patients must ask which is worse: living with fibromyalgia or seeking relief while living with the side effects.

An Elusive Cause

Medical science has not yet defined an exact cause for fibromyalgia. Some researchers suggest one's genetic background may be linked to developing FMS. Statistical studies show more women than men are diagnosed with FMS.

We are born with a nervous system that responds to both internal and external stimuli. At some point, due to one or more triggers, our nervous system begins to respond differently than it has in the past. We could say it seems to over-react.

Some of the triggers for the condition include:

Trauma, physical and mental
Major illness or infection
Serious injury
Extensive surgery

Think about this for a moment. In a doctor's room, there may be a soldier who fought in Iraq sitting next to a student with mononucleoisis who is next to a patient wrapped in bandages and a cast after a serious car accident. All three have a different reason for coming to the doctor but in addition to their individual condition, all three have fibromyalgia. Each of these circumstances has triggered a change in their nervous system.

Researchers seem to focus on one cause or another, seeking the key to this condition. I've come to compare fibromyalgia to a series of

The Long Term Effects of Prescription Drug Use

Prescription drugs are one of the marvels of modern medicine, curing infection and extending the life of many of our major organs. However, long term use of prescription drugs, no matter how necessary, does have an effect on our bodies.

Brain - Prescription drugs alter how the brain sends messages to the nerve cells throughout the body. In time, such changes may be irreversible.

Heart & Lungs - Long term use may have adverse effects on our cardiovascular system and blood pressure. As an example, look at the relationship between medication for heart disease and the negative effects of that medication on the kidneys.

Liver - The liver processes the food, chemicals and drugs we put into our bodies. Over time, long term prescription drug use may reduce liver function.

Intestinal Tract - As we age, our intestinal tract slows down, taking longer to process food. Some drugs cause constipation, making it more difficult to rid our body of waste.

Long term use of prescription drugs may require increasing amounts of the medication as our bodies become ever more tolerant of the chemicals we are taking. Prescription drugs may be important in our later years. When we are younger, we should strive to preserve the health of our bodies through exercise, proper rest and good nutrition.

jigsaw puzzles all interlinked, one to another. If we only focus on one piece of one puzzle at a time, we miss how the change in one puzzle interacts with the other puzzles. As an example, treating pain may improve our sleeping patterns, which in turn affects fatigue - very positive.

Dr. Frederick Wolfe, a leading researcher in FMS, has suggested that fibromyalgia is not an illness but rather a spectrum disorder. In other words, patients fall along a continuum, from the severest of syptoms to a mild discomfort. The condition is not static, remaining in one state. Rather, the condition changes, depending on many factors, including the weather, diet and activity level.

I'm intrigued by a theory proposed by Dr. Andrew Holman in 2008, focusing on compression of the cervical spinal cord. He believes that a low grade compression of the spinal cord could effect the nervous system, producing many of the sysmptoms exhibited with fibromyalgia. This pressure, not to be confused with myelopathy, is so mild it would not show up on an MRI. All of our symptoms can be tied into the nervous system but there may be other factors we haven't discovered yet.

One current theory that is gaining a lot of attention is the idea of central sensitization. This means that the sensors throughout our bodies are tuned to a higher level of sensitivity than the average person. The nervous system begins to send out signals of higher distress than is warranted by the conditions we are experiencing. This is currently called central sensitization.

Another theory addressing the sensitivity of the nervous system suggests that FMS may be due to lesions that have developed within the brain.

Other researchers are looking at the role of mitochondra in directing energy to the cells. Along with the mitochondria, other researchers are looking at the role of hormones produced by the different organs that our bodies require to work efficiently. Researchers have found that patients with fibromyalgia have a slight rise in glucose which plays into the study of hormones and fibromyalgia. All of these ideas are worth investigating.

Unfortunately, without a solid answer,

a number of theories rich in quackery have led those with fibromyalgia into some very strange and useless treatments.

Rather than devote further attention to singling out a cause, I choose to concentrate on how I am to live a full life with this condition.

Traditionally, the medical community has resorted to anti-inflammatories to treat the condition, with little success. More recently, Lyrica has come into favor as a treatment for the symptoms of FMS. Lyrica has some noteworthy side effects as shown in the chart on page 27.

I choose not to use Lyrica. I compare it to placing a band-aid on a badly infected wound. Lyrica treats the symptoms of FMS without treating the underlying cause. Lyrica does not cure fibromyalgia. It mere treats the symptoms.

I understand that not everyone can choose to follow a course of lifestyle management to treat FMS. However, I would suggest that many people, given discipline and support, would find that lifestyle management is preferable to the side effects of prescription drugs. Weighing the negative side effects and the use of a synthetic chemical formula, I came to the point where I was not willing to compromise my future health for the relief of the symtoms in this moment. This reasoning led me to stop using an anti-depressant I had taken for ten years.

As I stopped the anti-depressant, I read one doctor's opinion that prescribing female hormones would resolve the symptoms of fibromyalgia. I made an appointment to see her and she wrote out a prescription for a patch that dispensed estrogen, sending me on my way.

Taking estrogen disrupts my sleep patterns. Nine months after beginning estrogen therapy, I was living on very little sleep with a raging yeast infection. The doctor was too busy to talk with me. I told her assistant I could no longer bear the torment of the hormones and removed the patch.

Our bodies produce many different hormones and these do play a role in fibromyalgia. For some women, estrogen may play a role for a time, for others it is disruptive. Estrogen should not be taken solely for the

treatment of FMS. The fibromyalgia puzzle is much more complicated than adding a hormone.

As my sleep patterns returned to a normal pattern, I began looking at my lifestyle and the choices I was making. I chose to address the issues that contributed to the condition. This was a hard step to take. I was afraid. Could I handle the pain of fibromyalgia? What if the sleep disruption returned? I did not want to begin taking the antidepressant again.

You may have a similar story. You no longer want to deal with the prescribed drugs or their side effects. Looking at the list of symptoms, you wonder about other options. Could you live without the drug?

For me, the answers would not come in a pill. Instead I began to make some difficult changes. I still live with pain at times but the pain serves to remind me that I must pay attention to how I live.

Doctors now call this approach *Integrative Medicine*. This approach treats the whole person rather than just focusing on the symptoms. I cannot promise that such an approach would work for everyone but I do believe that many of the people who currently struggle with fibromyalgia would benefit from a healthier lifestyle.

Even if you would prefer to take a prescription drug each day, I would ask you to keep reading and think about what I'm suggesting. In the long run, you may decide to apply some of my suggestions to your life and be better for the effort.

Stepping Out

Recently I was in a furniture store looking for an upholstered chair - I have short legs with picky muscles in my shoulders and back. Finding a chair that is comfortable requires that I sit in a lot of chairs. As I shop, I will sit in each chair for a few minutes to see if my shoulders and lower back begin to ache. If you have fibromyalgia, you may have experienced this as well. During this process, I have lots of time to get to know the salesperson hovering around me!

On this particular day, I explained my challenge, the salesperson began to tell me that her sister had fibromyalgia. As this girl developed fibromyalgia, she hung out in bed, a lot. Her weight began to climb and soon she carried an extra 200 pounds on her five-foot, four-inch frame. Ouch! She frequently laid in bed and cried for the pain, for the weight gain, for the misery.

Then, one day, she got up! She decided on that day that she would live with pain but she didn't want to weigh 325 pounds anymore. She found she could walk a treadmill set to a slow speed. Each day she climbed on the treadmill and each day she took the pain medication she needed to manage the pain. As time went by, she noticed that her muscles were not quite so weak. She could pick up the pace a bit. Then, she raised the incline. Her muscles complained but she kept going, determined to live beyond the pain.

As the months went by, the weight began to melt away. She still hurt but overall, she felt better than she had in a long time. Today, this young woman has brought her weight down to 160 pounds. She still lives with fibromyalgia but she feels much better than she did at 325 pounds. She accomplished that task despite the pain, despite the fatigue.

Her story is not unique! Thousands of people afflicted with fibromyalgia can tell a similar story. Yet, I cannot tell you the number of times I have watched the defeat in a person's eyes when I tell them this is the alternative to the drugs doctors prescribe. They turn away, shaking their heads. They hate the drugs. They don't feel particularly successful using a drug regimen but fear holds them back from trying a course of lifestyle management for this painful condition.

I cannot confirm that practicing lifestyle management will work for everyone. However, a person with fibromyalgia has little to lose in making those first small steps toward a better life.

A Lifestyle Plan

Some have asked what I mean by lifestyle management. Simply, this means managing the different elements of your life to benefit your physical and mental well-being. Rather than feeling like a pingpong ball bouncing against the wall of life's demands and the symptoms of fibromyalgia, I began to examine how I was living.

Some people with fibromyalgia tell me they are ready to feel better. As we talk about the choices they make in their lives, they seem to have objections to every point we discuss. They have not reached the point of being willing to make changes. Instead, they want a doctor to prescribe a pill that will solve their problems. They have not taken ownership of their struggle with fibromyalgia.

When we struggle with pain and fatigue, it is easy to fall into the trap of thinking of our symptoms as something that happens to us. We're forced into a defensive posture, struggling against elements that threaten to pull us down into a sense of helplessness. How do we come to terms with a condition that has so many factors to consider? For some conditions, therapists may ask a patient to draw a picture of their pain. By defining the pain that is afflicting the bodies, the patient begins to establish boundaries to the pain.

Often those with fibromyalgia cannot define what causes the pain. Along with the screaming nerve ends, our muscles are quick to complain and break down. We have an area that feels as if it is on fire! If we could find a way to sink our fingers into the tortured nerve endings, we might bring the torture to account. We could find a treatment.

Obviously, we do not literally grab nerve endings. This is an analogy for seeking to define and take control of that which is afflicting us. When we accept ownership of what is afflicting us, we are ready to fight for change and to heal. We are ready to confront the factors that exacerbate fibromyalgia.

In thinking about how to manage fibromyalgia without prescription drugs,

I realized that unlike a pingpong ball I had to become very intentional about how I was managing my life. I could not change the diagnosis but I could take a careful look at the choices I was making and what was harming me.

I began by admitting my life was out of control. I lived daily with high stress levels, throwing myself into multiple projects. My relationships with family and friends were not healthy. The way I ate and rested left me unprepared for any challenge.

Just as I would never depart on a 24-mile hike through the back country without training and equipment, I also had to apply my mind to the discipline of establishing a healthy lifestyle. With these challenge identified, it was time to develop a plan to guide my progress forward.

Popular Prescription Drugs for Treating Fibromyalgia

Tylenol and ibeprofen in Advil may be sufficient to help with pain when other methods are not sufficient. Your doctor may recommend a prescription drug in the following catagories. In recommending a course of lifestyle management, I understand that not everyone can follow this course. I would recommend a thorough trial of alternative methods before resorting to a prescription.

Anti-depressants
Brand name: Amitripyline
Treats fatigue and sleep issues, questionable on treating pain.

Side effects: Weight gain, fluid retention, constipation, trouble concentrating, irritability

Norepinephrine inhibitor
(effects Serotonin - mood regulator)
Brand name: Dulosetine, Milnacipran
Treats anxiety, depression and sleep issues; Milnacipran treats cognitive issues.

Side effects: nausea, heart palpitation, headache, constipation, fatigue, high blood pressure, sleep issues and possibly thought of suicide.

Muscle Relaxer
Brand name: Cyclobenzaprine
Treats pain and sleep issues

Side Effects: Fluid retention, weight gain and constipation, trouble concentrating

Anti-seizure medication
Brand name: Pregabalin/ Lyrica, Gabapentin / Gralise, Horizant, Neurontin
Treats pain and sleep issues

Side effects: sleepiness, weight gain, dizziness, swelling of hands and feet

Analgesic - Opioid
Brand name: ConZip, Ultram, Ultram ER
Treats pain. (generic Tramadol)

Side effects: addiction, constipation, dizziness, headaches, nausea, fatigue

The First Step

To begin a program of lifestyle management, I recommend that someone with fibromyalgia sit down with a piece of paper and a pencil to take notes. Take a long, honest look at your life. Here are some questions to ask yourself.

APPEARANCE

What is your weight?
What is your BMI or Body mass index?
Too light, too heavy?
What do you want to weigh?

PAIN AND FATIGUE

Can you mentally construct a scale to describe the extremes you live through from the least to the most pain; no fatigue to motionless on the couch ? What level of pain do you live with on a daily basis?
Think about this and draw a scale depicting your pain.
Are you ready to accept a certain amount of pain if it will allow you to live without taking pharmaceutical drugs?

SLEEP & REST

Is sleeping restful?
How much rest do you get in a twenty- four hour period?
As you think about this question, consider this thought: There are the actual hours of sleep and then there is the time when we simply rest. Write down a total for each one.
What factors keep you from getting the necessary rest?

You want me to do what?
Pencil and paper?
I need a nap!

PHYSICAL EXERCISE

What exercises are you able to do now?
Everyone is at a different level - be honest.

DIET

What does your diet look like?

I'm not asking about a diet to lose or gain weight but rather what you eat on a regular basis.

Are you eating healthy foods?

Do you know what is healthy in the right proportions?

How much sugar are you consuming?

How much caffeine? Fiber? Salt? Fluids?

List each separately.

EMOTIONAL & PSYCHOLOGICAL

What causes stress in your life?

What percentage of your day do you feel as if you are under stress?

Do you feel overwhelmed at times?

If so, how do you handle the stress?

What unresolved issues from the past still haunt the corners of your mind?

What issues remain up front and center?

List them as they come to mind.

RELATIONSHIPS

Do you have a friend or a family member who is willing to walk with you though the difficult times when the pain seems to be overwhelming and you're mentally struggling to go on?

For those who have a religious background, take a moment to assess your relationship with God.

SPIRITUAL HEALTH

Are you aware of a spiritual side in life?

Are the physical demands in life so dominant that you have lost sight of your spirit?

What is your image of God?

Is God in control of your life or is he more of a consultant?

If something goes wrong, how do you see God reacting to you?

These questions address where you are right now. We'll come back to these later. If you've written down a few notes in answering the questions, set those aside.

Moving Forward

When we sit down to examine who we are and how we live, we find we have areas that need attention. Trying to coordinate all these demands for our attention may seem like trying to piece together a jigsaw puzzle.

We'll talk about each of these areas, one at a time. First, let's get an idea of how fibromyalgia affects you. Grab a second sheet of paper and write down each of the symptoms that effects you from the list below.

Pain

Skin tenderness

Fatigue

Stiffness

Difficulty sleeping

Depression

Gastrointestinal disruption

Head aches

Loss of sensation in fingertips

Sensitivity to bright lights or certain sounds

Heart palpitations

Light-headedness

Mood swings

Anxiety

Brain fog

Looking at this list we can see that we might place each of these under the three areas of concern discussed earlier: Pain, Fatigue and Cognitive Challenges. The tender or burning skin and headaches fall under pain. Difficulty sleeping, depression, mood swings and anxiety fall under fatigue.

The brain fog could be related to both over-reaction of the nervous system and to fatigue. My brain processes information more clearly when I am well rested. However, there is something more to the cognitive challenges of fibromyalgia that science cannot yet explain.

The sensitivity to either bright or flashing lights and certain sounds is definitely related to a nervous system over reacting as suggested by the theory of central sensitization. The gastric senstivity may also be linked to a nervous system that is overly sensitive.

We can begin to address each cluster of symptoms and look for improvement or the lack there-of with the changes we are making to our lifestyle.

Before I begin discussing the symptoms

and the means to treat them, we need to think about who we are. I don't mean your name, what you look like or how you are employed.

As unique individuals, we are made up of body, mind and spirit. Our body is the physical frame in which we dwell. Our mind includes all the things we remember, how we respond to others, the damage to our psyches and what we think about during the day.

And then there is the spirit. When we think about spiritual influences in our lives, many people become uncomfortable. Think for a moment. We are more than animals. There is something that allows us to contemplate the sense of right and wrong, the future and the immortal. I believe that element is an important part of maintaining our balance as an individual. It is closely tied to our mental state and often exhibits through our physical condition.

As we approach the idea of lifestyle management, we are seeking to balance each of these areas of concern with each other.

Our being consist of: Body, Mind and Spirit. To be whole and healthy, all three must seek healing.

Fatigue: Seeking Rest

Let's start with fatigue. I had long struggled with a sleep disorder. After birthing three children, I found that 16 hours of wakefulness did not stretch quite far enough to allow me to accomplish everything that needed to be done. I began getting up early and staying up late. Very late! In the process, I destroyed my natural sleep patterns.

Others with fibromyalgia simply do not go to sleep because their sleep patterns are not in line with the circadian cycle of light and darkness. Many of us spend much of our day indoors and this disrupts our circadian rhythm. Sunlight suppresses melatonin, a substance our bodies produces to help us sleep at night. In the circadian rhythm, as the shadows lengthen and sunlight disappears into the evening hours, our body should begin to release melatonin. If this cycle is disrupted with artificial light, our bodies may quit producing melatonin. Older people often experience a drop in the production of melatonin.

Researchers have found that spending time outside mid-day helps maintain our natural circadian rhythm. Taking a break at noon for a short walk helps our natural cycle as well as helping our bodies produce vitamin D.

Sunlight may also cause our bodies to release serotonin, a chemical that helps us feel calm and focused. Both serotonin and melatonin are necessary to feeling well-balanced. The healthiest way to obtain both is through spending time outdoors.

Unfortunately, sleep medication does not reset our sleep patterns and may actually make the problem worse. Some take synthetic melatonin and still experience periods of irregular sleep after the minimal six weeks. Rest becomes even more important at these times.

When I was first diagnosed with FMS, I learned that part of my fatigue was that I was not moving into the phase of sleep known as REM or rapid eye-movement sleep. There are four phases of sleep. In the third phase which our deepest sleep, blood flows into the muscles and hormones are released.

With REM, the fourth stage, the hormones work to repair the damage that has been done during the day. This is also the stage when our brains process much of what has happened during the day. If we wake and don't feel rested, we may have a sleep disorder. The doctor may order a sleep study to see what is actually happening through the stages of sleep.

I dislike anti-depressants but these may have a role to play in re-establishing correct sleep pattern. If prescribed, such a medication should only be used short term and reduced in stages when discontinued.

One doctor I consulted recommended Tramadol rather than an anti-depressant. Tramodol is a mild opiod which helps patients sleep and relieves pain. As an opiod, this drug can be addictive so it should only be used short term to re-establish a sleep pattern.

Before resorting to drug therapy, we might examine how we approach the time we sleep.

Barometric changes as a storm front moves in, can disturb sleep patterns for those with FMS. When the storm passes, the next night will be better.

We've lost the art of bedtime preparation in allowing our bodies and minds to slow down after a busy day. Watching television keeps our brains in an elevated state of attention.

Think about how our culture has been transformed by technology. Unlike our precedents, we work with computers much of the day. We check the screen of our phones repeatedly. Once we are home, the television is turned on - another screen. All of these screens emit a blue light which mimics natural daylight. The blue light from a television or computer counters the effect of natural melatonin.

If you're struggling with sleep, turn off the television two hours before bedtime. Set aside the smart phone and pick up a book. Enjoy a cup of herbal tea meant to calm the mind. Avoid intense conversations.

Caffeine is a stimulant to the nervous system and many of those with FMS should be cautious with how much caffeine is consumed later in the day. The half life of caffeine when the chemical most actively effects us is six hours. If I'm concerned about sleeping, I prefer to avoid caffeine throughout the afternoon and evening.

When we go to bed, it helps if the room is dark and quiet. Many people prefer to sleep in a cool room with enough blankets to be warm.

There are nights, when despite my best efforts to relax before going to bed, my mind is still roaring over the day's events even as I try to sleep. If something is troubling me I make a few notes and set the notes aside for the next day. My mind may seek to stir the topic again but I have released my concern to the sheet of paper where it will be waiting for me the next day. My mind will continue to work on this topic even as I am sleeping. To refocus, I may read a bit more before returning to bed.

Opiods are addictive and can cause further side effects! The one exception I consider using on a short term basis is Tramadol. Many doctors will tell you that Tramadol is not as effective as other opiods. However, it is a little easier to stop using than other opiods and may be useful for pain after an injury or severe illness when extra rest is required.

Achieving rest is more than a physical preparation, it is also preparing our minds to rest. Once we have settled into a regular pattern of sleeping, we may find that the fatigue has improved.

When we don't sleep, it is still important to maintain our schedule and try not to inflict our weariness on others. There is a good chance we'll get some sleep the following night.

Rest!

By resting, I don't mean sleep. We need times during the day when we seek inactivity.

I'm a person who charges through the day. Years ago, I analyzed how I was spending my time and found that I had gaps of time I frittered away between major tasks. I thought I needed to be more disciplined and use those gaps to accomplish little things for which I never seemed to find time. I was amazed at how much I got done! Yet, the constant activity left me little time to recharge my level of energy.

To rest means we set aside a time to allow our nervous system and our muscles to rest without introducing new irritation. Rest is intentional, it has purpose. Being idle is not the same as rest.

We listen to our bodies. When we feel a bit overwhelmed or fatigue starts to set in, we take time for a restful activity. For those pounding the computer keys, this may mean a short walk outdoors followed by a few minutes of meditation. For those on their feet all day, it may mean a few minutes with the feet up and eyes closed. Within ten minutes, our bodies should rebound and be ready to resume our activity.

Rest is essential to managing fibromyalgia and cannot be skipped because it is inconvenient. Each person will learn how much rest is required for them to maintain a good level of activity.

Returning to the sheet where you first listed your symptoms, write your ideas for times of rest in your schedule.

Pain

One of the two most common complaints about fibromyalgia is the pain. Pain may be the result of inflammation, of physical

over-exertion or mental anguish. Responding to pain is more than swallowing a pill.

With physical injury, researchers catagorize pain into two catagories: *Nociceptive* and *Neuropathic*. *Nociceptive* pain comes when the tissues in our bodies are injured. Most of us are familiar with nociceptive pain from bruises, cuts or broken bones. *Neuropathic* pain comes when the your body is reporting an injury involving the nervous system. There may be no outward sign of the injury. An example of neuropathic pain is a pinched nerve.

The pain from fibromyalgia does not fall under either classification. One researcher suggests that we label the pain of fibromyalgia as algopathic pain, meaning pain without a specific source. The disfunctional pain from fibromyalgia may not have a source we can pinpoint, meaning that some element in

**Managing
Painful Flare-ups**
Painful flare-ups indicate that your body is sending a message. Sometimes those messages are hard to read because we don't want to hear the message or we don't know what our bodies are telling us.

Stop!

Take time to assess what is happening. Then choose what factors you can control to improve the situation.

our body is behaving poorly, whether it be nerves, muscles or skin. Pain from an injury may evolve into algopathic pain, causing further confusion.

Researchers believe that fibromyalgia amplifies painful sensations by affecting the way your brain processes pain signals. The Mayo Clinic suggests that advanced brain scans show that the brains of those with fibromyalgia respond to pain stimuli at a much more significant rate than those without fibromyagia.*

While most of us are born with a basic brain structure, the experience received over a lifetime changes the structure of our brain. The areas of our brain that we stimulate will grow strong and develop well while those areas that receive little stimulus

Mayo Clinic Guide to Fibromyalgia, Andy Abril & Barbara K. Bruce, Mayo Foundation for Medical Education and Research, 2019

will not develop at the same rate.

In responding to pain, the pathways to the pain sensors in our brains become well established. Just like a muscle that is used regularly, these pathways receive encouragement to develop. For those with fibromyalgia, the pathways reporting pain pain to our brain demand ever more attention.

How do we respond to pain? Obviously, pain medicaton is one choice, along with alternative therapies. Exercise also plays a role in creating a physical and mental balance with pain management.

Let's begin by identifying the role of pain in our lives and then looking at measures to respond to pain.

I asked you to construct a scale to measure the pain you live with. On this scale, list a specific time when you were at your lowest pain level and a time when the pain was raging out of control. Think about specific events or dates like a wedding, a vacation or a project at work. Note that date and a few of the details on your scale such as the factors that contributed to the lack of pain or the increase in pain. Do the same with fatigue.

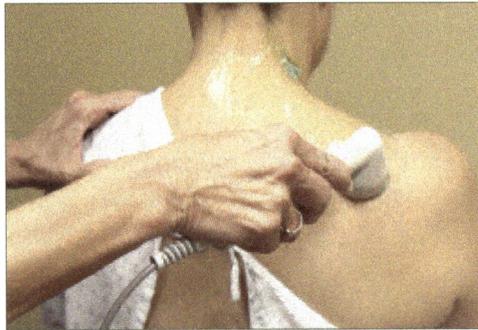

Ultrasonic waves create heat deep within the tissue while leaving the skin surface cool. The gel helps reduce the friction of the wand against the skin. Some patients find the treatment highly effective for reducing pain while others receive no benefit.

In the future, when pain makes an appearance, this can be a scale by which to judge the severity of the pain and how we respond. This may help you to recognize what triggers your pain and fatigue.

When I first went to my doctor about the pain in one elbow, he prescribed an anti-inflamatory medication. If the pain had been the condition known as tennis elbow, this might have been helpful. When I returned a week later, there was no improvement. Fortunately, I was referred to a rheumatologist who understood what was happening.

For many people, any amount of pain is unacceptable. I have found, as have others, that I can live with a small amount of pain most days. I am so used to this that I mentally block the pain from my awareness. This lack of awareness can be both blessing and curse. The pain is my warning to be careful. If my awareness of pain drops, I easily press beyond what is acceptable.

When pain first makes an appearance, it is important to understand whether one is dealing with nociceptive, neuropathic or algopathic pain. Nociceptive pain tends to respond best to ibeprofen while Neuropathic pain may respond better to acetaminophen. Today, many practictioners are recommending both acetaminophen and ibeprofen together when the pain becomes significant.

Knowing my kidneys must process these drugs as they flush through my body, I would prefer to try some other methods of pain relief for persistant pain before swallowing a pill.

There are other options for dealing with pain without using either over-the-counter or prescription drugs?

Heat
Ultra-sound
Massage
Cupping
Alternative therapies

Let's look at each option, starting with the use of heat. When the neck and shoulders become inflamed, I have a fluffly sock filled with rice that I heat in the microwave and place over the sore area like my neck and shoulders. For a strained back, I prefer a heating pad. When the pain in my lower back is extreme, I may sit pressed against the pad for up to four hours to gain a lasting measure of relief.

Physical therapists will insist that heat should be alternated with cold to reduce inflammation. Therapists are beginning to realize that many with FMS do not benefit from use cold packs. The cold packs causes their muscles to tighten, increasing the pain.

Another option is to find a practitioner who will apply ultrasound to the imflamed area. Some who have tried ultrasound are confused by the lack of warmth as the wand

moves across the skin. The sound waves are working deep below the surface to ease tense muscles. A gentle massage after the treatment enhances the benefit of the sound waves.

Finding a practitioner who believes that the ultrasound may be beneficial is not easy. Nor does every patient benefit from the ultrasound. Each person has to evaluate the treatment for its benefit.

For many with FMS, immersing in warm water can be therapeutic. Hot tubs have become very popular in this country as a means to soothe sore muscles and joints. The warm water allows the muscles to relax and healing to take place. In European countries, the sauna is more popular but may achieve the same effect.

Along with warm water, massage may be helpful in relaxing tight muscles. I find that there is a distinct difference between a massage from a physical therapist and a masseuse. Be careful! The physical therapist understands the damage that can be created in manipulating the muscles.

In another session, an inexperienced masseuse began a pinching-twisting movement along my spine that was very painful and created a flare-up. Always check their qualifications before allowing a masseuse to begin working.

Those with fibromyalgia complain of a general burning or inflammation across the surface of the skin. The burning sensation is caused by the nervous system over-reacting to stimmuli but it seems impossible to pinpoint the cause of the pain. This is one type of pain that may respond well to the use of a cool pack. I also like the use of thick moisturizers like Eucerin. It is difficult to touch the inflamed skin with the cool cream but relief comes fairly quickly.

If this is insufficient, I may add a patch that treats pain such as the Salonpas patch with menthol, or more extreme, a Lidocaine patch.

When the pain cycle begins to crank upward, many patients find a massage is helpful. I began working with a physical therapist who dug into my tight muscles. When I was locked into the pain cycle with little range of motion, she became one the keys to unlocking the pain that held me in a tight grip.

Recently my therapist tried a technique called cupping after I over-reached and strained a muscle. Cupping gained attention when a swimmer at the Olympics showed up with round circles on his skin. Skeptical about what a plastic cup could do to relieve pain, I was thrilled the next day when the pain was significantly reduced.

Other patients find that acupuncture or dry needling will help find the correct balance to resolve issue with pain and fatigue. Acupuncture seeks to restore the balance and harmony in our bodies by working through internal energy channels.

Dry needling works with muscle and connective tissue to diminish pain and restore normal function within our bodies. The two techniques use needles but have a different emphasis.

We understand when a wound is red and slightly swollen that it is inflamed. Healing begins as blood and anabolic hormones flow into the wound to heal the break in the skin. When a wound does not heal the body has slipped into a destructive inflammatory cycle. A doctor may clean out the wound,

Natural Chemical Relief
~ from Webmd.com ~

"Endorphins act as analgesics, which means they diminish our perception of pain. They also act as sedatives. Endomorphins are manufactured in your brain, spinal cord, and many other parts of your body and are released in response to brain chemicals called neurotransmitters. Endorphins bind to the same neurons in our cells as some pain medicines. However, unlike morphine, the activation of these receptors by the body's endorphins does not lead to addiction or dependence."

Regular exercise has been proven to:
* Reduce stress
* Ward off anxiety and mild depression
* Boost self-esteem
* Improve sleep

I would much rather stimulate natural endomorphins for relief than rely on a synthetic chemical!

brushing or abrading the damaged area to reset the healing process. The body rushes hormones to the site and healing finally begins.*

The dry needling follows this same pattern. Thin filiform needles are set in a trigger point, resetting the healing process and summoning hormones to the wound.

Another avenue some fibromyalgia patients are pursuing is is the searing or ablation of a nerve. I personally would like to see more research done with this before I tried ablation for fibromyalgia pain.

The Gift of Pain

Living with chronic pain is a struggle. If we could rid ourselves of pain, our quality of life would improve.

However, consider those who are unable to feel pain, specifically those with Hansen's Disease. As their nerve endings die, pain no longer warns them of damage to their bodies such as a burn from handling a hot pan.

In that context, those with fibromyalgia might consider pain as a gift. Pain warns us that we are damaging our bodies. Pain cautions us to stop and consider what we are doing. Pain reminds us to slow down and heal.

Exercise

When fibromyalgia pain develops, our first instinct is to draw into ourselves. I want to roll into a ball and protect whatever part of my body is in pain. With fibromyalgia this can actually be counterproductive. As our muscles tighten, the pain increases.

Exercise is actually one of the most important means of treating fibromyalgia. Such an idea seems counter-intuitive. If I hurt why should I move? Better to rest and wait for the pain to pass.

No! Time to get off the couch. Time to get out of bed and move!

Beginning the day with a good routine in stretching is important! I start with a couple of deep breaths from the diaphragm, allowing my shoulders to slowly drop. This allows the shoulders and back to relax. I slowly tilt my head to either side and forward, then turn my face to either side, stretching the neck.

With another deep breath, I gently reach

* Anabolic and catabolic hormones must be in balance for proper healing to begin. You can read more in the January, 2005 issue of the National Institute of Health Journal in The Role of Anabolic Hormones for Wound Healing in Catabolic States, an article by Robert H. Demling, MD.

overhead before lowering my arms to either side. I begin to rotate my arms in small circles, moving to larger, gentle looping gestures.

Deep breathing through the exercise releases endomorphins thoughout the body which bring a sense of wellness and relaxes the muscles.

Next I bring my arms forward as if pushing someone away. Then, I bend my elbows backward with my wrists alongside my waist, before pushing foward again. I repeat these movements several times allows my bodies to warm to the day.

Bending at the waist, I touch my toes, before bending to either side. Spreading my feet, I turn at the hips, gently one way, then the other. Some people drop to the floor and bring one leg over the other, repeating to the opposite side each side. There are many variations to this routine.

Stretching helps us to warm our muscles against the stiffness that is a part of fibromyalgia. Stretching can actually leave us limber for the rest of the day. If we end up in one position for an extended length of time as I do in front of a computer, it is good to stretch again. The stretching helps to prevent musculo-skeletal injury.

While stretching is a great start to the day, it is not enough to counter the debilitating effects of fibromyalgia.

If a movement hurts, back off. Approach the same movement again, gently. With each approach, you should get a little more range of motion.

I've read about a biopsy performed on the muscles of those with fibromyalgia. When the the muscle tissue was placed under a microscope, the edges of the muscles were ragged as if they had been subjected to rigorous activity without the chance to heal.

This is an interesting thought to consider while I'm struggling to warm my muscles during stretching in the morning. This same thought returns after an injury when I've ignored the silent cries of pain that warned me to slow down.

In our town, we have an older man who rides a trike, slowly pushing down one pedal, then the next. He once told me that if he fails to ride each day, upon the next day, he can already feel the deterioration in his muscles. His efforts look painful, but I respect his struggle to maintain his mucle tone.

When we are in pain, when fatigue steals every ounce of energy, the last thing we want to hear is the need to exercise. I'm not a fanatic about exercise but I have come to recognize the importance of this in treating FMS. The Mayo Clinic seems to have arrived at the same conclusion in their research.

Exercise helps our bodies function better from the brain down to the expulsion of waste. Exercise introduces important chemicals into our bodies that subdue pain and release a sense of well-being.

Beyond Stretching

The traditional approach to physical fitness through exercise involves pushing oneself to increase endurance and strength while shedding pounds and building muscle. For a person with fibromyalgia, such an approach can bring on a significant flare-up of pain and fatigue. Why would anyone want to get off the couch and do some-

Walking is an excellent form of exercise as is riding a bike, providing you don't fall off!

thing that hurts? We struggle with finding an approach that allows us to exercise without causing a flare-up.

The secret lies in a measured approach that may cause a minimal amount of pain while building muscle. With each advance, we trade a few days of pain toward becoming healthier and feeling better. These results cannot be obtained through a pill regimen.

One of the biggest challenges for those with FMS is to build muscle strength. Biopsies on the muscles of fibromyalgia patients have shown ragged red fibers. What does this

indicate?

One research team has found an uneven distribution of mitochondria in the cells of the mucles of those with fibromyalgia. Mitochondria, as I understand it, breaks down the nutrients the body receives and produces energy within each cell. If the mitochondria is spread unevenly it may affect how our muscles repair and perform when under duress. The ragged fibers may indicate that the muscle is not being repaired as it would in a person without fibromyalgia.

Other researchers have looked at micro-

circulation within the smallest blood vessels and whether the muscles are receiving adequate blood flow which could effect muscle performance. Both of these studies need more research.

 In talking about getting and staying fit, I am not suggesting that a person with fibromyalgia burst out of their home and enter a marathon. I cannot imagine a faster way to a major flare-up that will kill any good intention. Instead, be intentional.

 1 - Listen to your body.
 2 - Move at a wise pace,
 running your own 'race'.
 3 - Avoid those who want

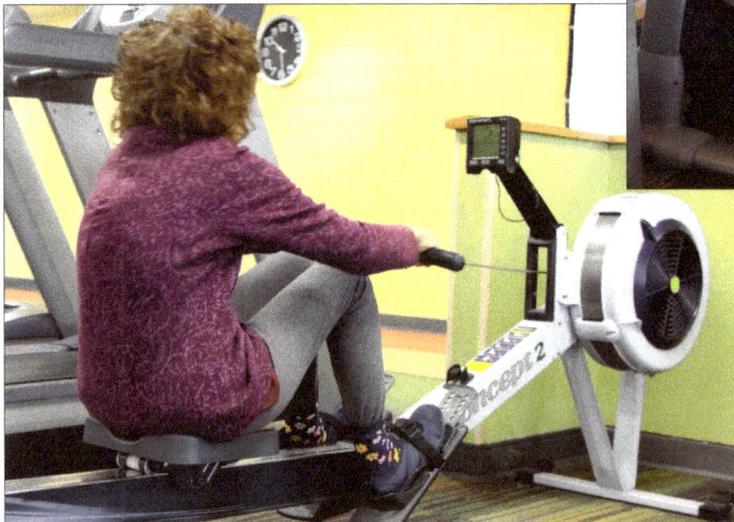

left to right:
Rowing Machine
Ellipticals
Free -weights
Machine-based weights

to help you who do not understand fibromyalgia.

I have often run into athletic trainers or exercise buffs in the gym who listen to what I have to say, nod their understanding and then offer recommendations that would cause a flare-up. I cannot stress enough that it is important to work with moderation!

 Start small! When you wake up in the morning, establish a routine of slowly, gently stretching every major muscle group. Don't push deeply into the pain. If a movement hurts, back off. Approach the same movement again, gently. With each approach, you should get a little more range of motion.

After warming up the muscles, begin introduc-

The secret to exercise lies in a measured approach that may cause a minimal amount of pain while building muscle.

Pushing too hard and too soon may cause inflammation. This will require more time in recovery and could be self defeating.

Everything we do contributes to the formation of our brain. Pain can alter how a brain functions. Moderate exercise is a healthy response when the pain begins to build resistance in your brain.

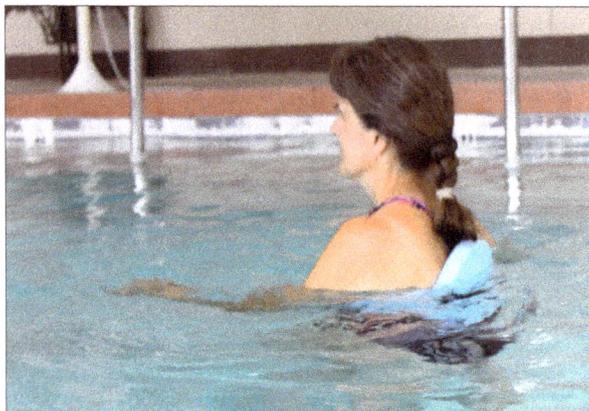

Water jogging involves no impact to our joints. As the styromfoam belt supports the water jogger, it is important to maintain an upright position to get the most out of the exercise.

ing mild forms of non-impact exercise into your routine. Anything that involves a part of your body hitting another surface is impact. Impact can mean something as commonplace as clapping one's hands or walking briskly. I have found as the years go by, my lower back and hips can no longer take the impact of walking briskly on hard pavement.

In response, I moved to a treadmill, increasing the incline while maintaining a fairly low speed. By increasing the incline, I get more of a cardio workout but also shift my weight from my heels to the balls of my feet. The stress of impact no longer shudders through my heels, up through my knees and hip joints and into my lower back. As I grow stronger, I am able to increase the incline and speed.

Since then, I've added an elliptical machine to my workout. The movement is similar to running but since my feet stay with the machine, I avoid the impact. Hiking on a natural surface like a dirt trail is also an option which decreases the impact on our feet, legs and spine.

Moving on to the weight room, using the same principle - I stick with weights I can easily handle rather than over doing my lifts. As

a level became too easy, I gradually increased the weight in small increments, avoiding a flare-up in pain. The benefit of weight lifting is that as muscle strength increases, we protect the muscles from injury.

Rowing machines are often found in weight rooms and I've learned this is a great full body work-out. Get a rhythm going and you hate to stop the methodical movement.

Some people like tai chi and yoga as an important part of a good physical regimen. These forms of exercise certainly stretch the muscles at a measured pace while building strength and balance.

For those who enjoy the water, swimming is an excellent form of exercise and unlikely to strain muscles. A second form of exercise in the water that combines swimming and running is water jogging. A flotation belt supports the swimmer in deep water but the lack of a hard surface requires the person to kick forward, drawing the legs back against the resistance of the water. With persistance, the water jogger crosses the pool from one side to the other and back.

During warm weather, I frequently rode a bike to work. Each day, my muscles muttered that this seemed like a lot of effort. Each day as I started the ride, my body complained about the effort required to push the pedals. After about a mile, an amazing feeling crept through my body as as I loosened up and enjoyed the ride. Not only was my body responding but my mind was engaged. I exulted in being outside and in the freedom of movement. The natural chemicals my body produces kicked in and I felt good!

When completed, exercise helps us to sleep better. However, exercise should be completed, if possible, before evening arrives. Our bodies do not need the stimulation as we move toward the time we intend to sleep.

Every person struggling to balance fibromyalgia and exercise has their favorite stories about how they suffered a flare-up. Yet, when they healed and went back to the basics, they were able to once again establish an exercise routine that left them feeling better. Working out consistently will reduce the pain from fibromyalgia. Along with the physical benefit, exercise helps improves out mental alertness and relieves mental gloom.

Returning to your worksheet, jot down some ideas on pain management.

Cognitive Challenges

The first time I heard someone refer to brain fog as part of fibromyalgia, I wondered about her rational thinking! I have since come to respect the cognitive challenges that some face with fibromyalgia. Defining brain fog generally means that the brain processes information more slowly. Mental calculations seem muted. Our short-term memory becomes an issue. Multi-tasking or keeping several tasks going at once becomes very stressful and for some nearly impossible. Confusion can set in as stress mounts.

Nobody wants to admit that they are not as sharp mentally as they once were, especially individuals who are driven to succeed. When encountering brain fog, it is time to assess what tasks we can do and what has become a challenge. For some people, simply handing off a particular task to another person may be enough to manage the brain fog. For others, brain fog may require a complete change of career to something less demanding or less critical. This can be emotionally difficult but consider the benefits in making these changes.

We will not make mistakes that costs other people time and effort. Less stressful employment is not so physically draining and leaves us with a better self-image. We can emphasize what we do well and enjoy life more.

I've heard from others who have gone through a career change that they found a more relaxed atmosphere in keeping with their capabilities. A slower, less demanding pace did not leave them feeling so drained. Moving out of a job that requires extensive multi-tasking to concentrate on more relaxed social interaction allows them to enjoy working while reducing stress.

For those marginally challenged by brain fog, keeping a list of written activities for the day with little side notes helps the short term memory. Working on a project with a co-worker may help keep us on task when our minds start to fog. Short breaks to assess our progress may also help us to focus.

If fibromyalgia, costs us a job or a hobby, it is important for our mental well-being, to find something of value to replace what

Stepping Up To The Grand

For two decades I lived with fibromyalgia. I wrote about outdoor Arizona, pushing my body through the challenge of hiking and camping while in pain.

Now, I wanted to hike the Grand Canyon! Goals are good but I wondered if I was over-reaching: twenty-four miles, walking through harsh terrain while carrying a heavy pack and sleeping on the ground. Not only did I need to address the challenges of the Grand Canyon but I also had to consider how I would respond to these challenges with fibromyalgia.

I needed to train. Would training be enough to prevent damage to my body?

Deep in the Grand Canyon, there are no Emergency departments. The Park Rangers take the approach that if you got yourself into the canyon, you could get yourself out!

I live in Flagstaff, just ninety miles south of the Canyon, in the middle of a cinder cone field. Just over a thousand years ago, this part of the North American continent was a hot, smoky place with cinder cones belching gas and ash.

Today, the remnants of this volcanic activity dot the terrain of northern Arizona. Trails twist up the sides of these cinder cone with elevations rising from 7,000 to just over 12,000 feet. The Forest Service with crews of recreation-minded people have laid out trails throughout the region. These peaks became our training ground. Each week I would grab a pack and a walking stick and join a friend for a day hike up the side of another peak.

A second, shorter hike each week helped add more muscle.Along with the hiking, I went to the gym four days a week and added stair stepping and weight training to the regimen. So, what happens when we add so much training to a normal exercise routine?

Pain! Of course. Knowing this could happen, I eased into the routine, steadily conditioning my muscles. I did not just jump off the couch and run off to the next 20-mile hike. I started small and gradually increased the distance I hiked.

When my muscles were sore, I dealt with the pain by soaking in a hot tub and taking small amounts of ibeprofen for a couple days after each hard climb. After a month, my muscles had strengthened to the point where I lived with mild discomfort, knowing that the pain would recede within a couple of days.

One afternoon, as we steadily climbed a peak, I found myself leading my companions up the trail. One commented, "You've never led before. You are really making progress."

The one mistake I made in training was waiting too long to add weight to my pack, simulating the conditions we would face as we descended into the Grand Canyon. We had been hiking for months and just two weeks before we were to leave I started carrying a heavier pack.

One of the biggest challenges in hiking the Grand is the extremes in climate between the canyon rim and the depths of the inner canyon. The daytime summer temperature on the rim hangs around 80 degrees, give or take a ten degree variation. In the winter, cold winds and snow move in, leaving the trails icy with temperatures dropping to freezing or below at night. Access to the North Rim is closed from November to mid-May, meaning that cross-canyon hikers must start from the south rim, cross the canyon and then return. We planned to hike during the warmer months.

Like most people, we did not want to hike in temperatures over 100 degrees. The spring and fall seasons are the most popular time to cross the canyon. We were issued a permit the first week of September. We could not know four months in advance that this would be one of the warmest Septembers on record.

The permit allows each party to contain up to six hikers. Permits are available for larger groups with only one site available at the campground below the North Rim. My hiking partner was eager to bring the maximum number of people allowed on the permit and therein I learned another valuable lesson in living with fibromyalgia.

Choose Not to Walk Alone

Fear and discouragement are close companions of pain and fatigue. When we are discouraged, encouragement is a great gift.

Everyone needs encouragement! Walking with another person through a difficult time allows us to lean on the other when we are struggling, both mentally and physically.

I knew that pain and fatigue would be an issue in the Grand Canyon as it is with any other challenge. When we are in a comfortable moment, we may become convinced we can stand on our own two feet, but one strong dose of pain and fatigue undermines us. As we plunge into a major flare-up, we wonder what all our efforts accomplished. Are we making any progress at all?

My hiking partner began approaching other women she knew who enjoyed hiking. These women would respond well to a physical challenge. She filled the permit. I was to discover as we descended the Canyon that my hiking partners did not understand the limitations of fibromyalgia or the habit of a photographer for stopping at every bend to take another photo! Within the first few switchbacks, I quickly found that I would be hiking alone as the others scampered down the trail.

When we are struggling, we need a friend who will listen to us fret and complain about the pain. A friend who will prod us to keep moving when we hurt, encourage us not to give up. That one person to whom we can empty the storehouse of grief that belabors our soul.

This person will show an amazing combination of patience, encouragement and perseverance as they push, comfort and encourage us to take the next step. Such friends are few and far between. They are the ones jumping up and down on the sidelines when we count our first achievement. They remind us of how far we have come when despair threatens to wipe us out. That person pushes us to take the next step when we falter.

Not just any person will do! Sometimes it takes a cautious approach with some false starts to find the right person or people who will give us the encouragement so vital to feeding our soul.

Of the five woman who joined me, one friend stood out in her sensitivity. She knew when to drop back and stay with me. She knew when she could leave me to wander along the trail alone.

Sometimes such a person may catch us

unaware. I remember a day when a spasm of pain hit unexpectedly. As I dropped to the floor, crouching and wrapping my arms around my sides, a friend instantly began to murmur, "Breathe, breathe! With her encouragement, I was able to relax as the spasm passed. Often, it is my husband who steps forward to handle simple tasks until a muscle spasm ends. He would play a significant role as we came out of the Canyon.

Another Lesson

With permit in hand, the day came when we were scheduled to leave. To drive from one rim to the other requires a circutious route taking about three hours. Circumstances prevented us from reaching the trailhead until late morning. This was much later than we should have left. We tumbled out of the van and gathered our packs and belongings. Each of us was paired with another hiker, helping to share the load of a two man tent and other supplies.

My partner had insisted that she carry the tent and then realized that it would not fit in her pack. Now I faced a choice. Did I unpack and cram the tent inside my pack? Or did I find a way to fasten it to the exterior of the pack before getting under-way? My hiking partner was sure she could cram the tent into the front pocket of my pack.

I lifted the pack onto my back and wondred how I thought I could ever carry such a weight. The weight of the tent as light, as it was, pulled the pack backward, placing extra strain on my shoulders instead of over my hips. I was looking at the real possibility of of an injury.

Within the first quarter mile, as the others surged ahead, I stopped. Another woman quietly helped me move the tent to the top of my pack, precariously balanced with a bungie cord. The strain shifted but I knew that the threat of an injury remained.

From years of experience, we both knew how important it was to balance the pack but we were in a hurry to get down the trail. I chose friendship rather than exercising good sense. This is something we must bear in mind when we listen to other people in making a decision. It is important to kindly advocate for yourself, even when you feel uncomfortable doing so.

As it turned out, it was a good thing I took the tent as my partner developed blisters on her feet within the first four miles. The extra weight would have aggravated the blisters.

The Heart of the Canyon

The Grand Canyon from the rim appears to be a maze of rivelets trapped between giant stone monuments. This is not a book about the wonders of the Grand Canyon but allow me to describe to you a couple of highlights that made the journey special.

As a hiker delves into the depths, the canyon reveals its hidden secrets.

I remember standing below a soaring sandstone cliff and gazing up at the desert varnish painted on the rock by streams of snowmelt as if an artist had swept a brush across the cliff.

By mid-afternoon we came to the first bridge. There is something special about

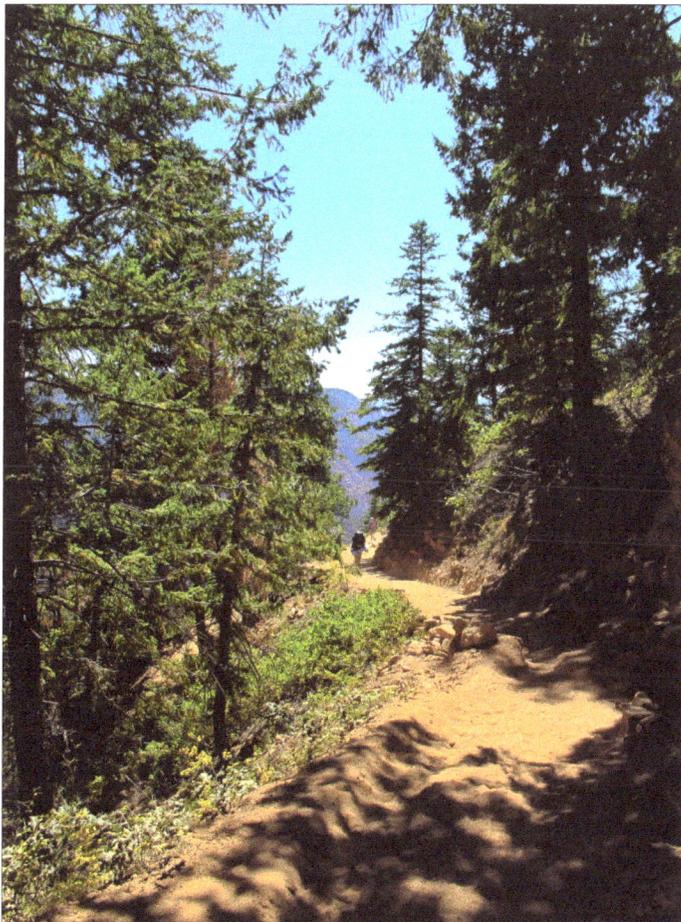

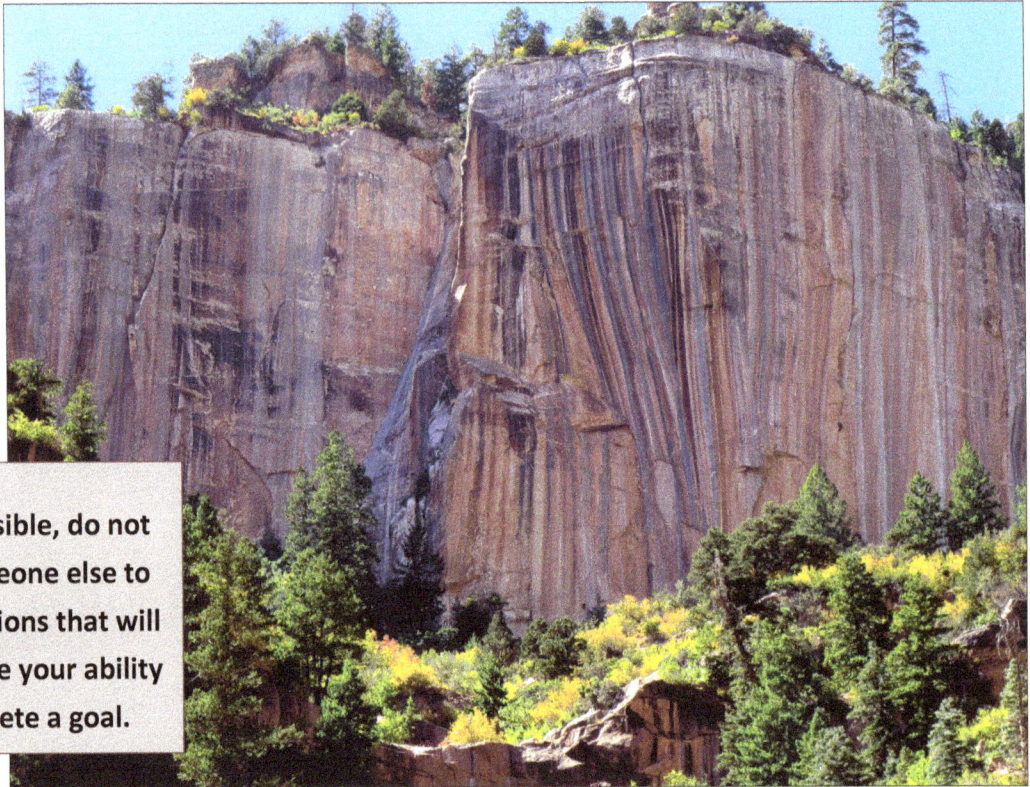

When possible, do not allow someone else to make decisions that will compromise your ability to complete a goal.

bridges as they take us from one side of a chasm to the other.

We stopped for a moment to examine my partner's blisters and then resumed the steady pounding of one foot beyond the next. My partner suddenly stopped and exclaimed, "Oh, wow!" I hurried forward to gaze across a scene that might have come from a movie set. Below us the trail dropped through a cleft and turned to follow a cut across the face of a cliff. Overhead, breaks in the cliff allowed shafts of light to flow across the narrow canyon creating a dramatic landscape.

Friends called to us to keep moving and we soon hurried past the home of the pump-house keeper. Briefly I thought of how comfortable it would be to stay under their roof but turned toward another bridge across Bright

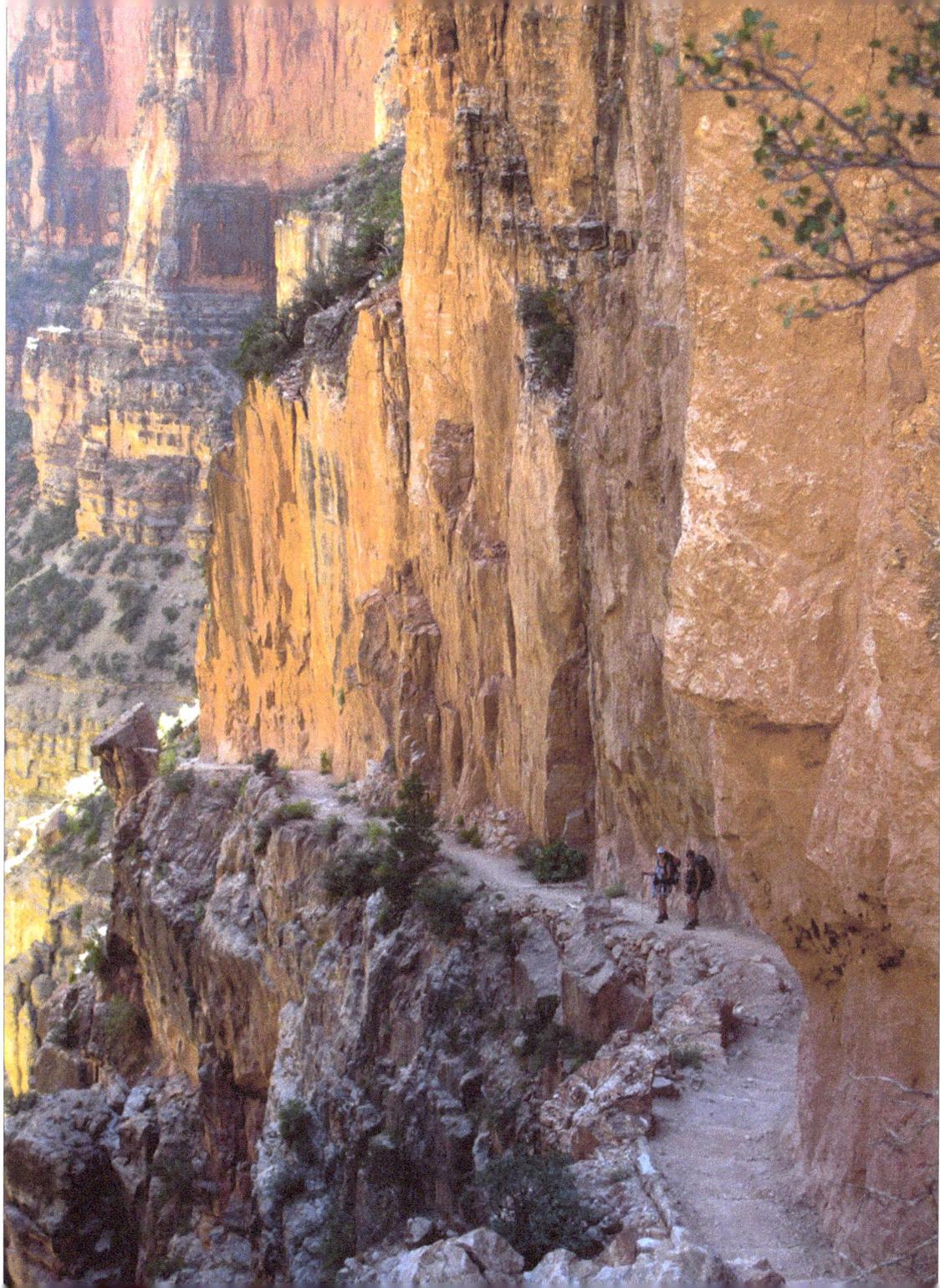

Angel Creek with its lively current and small cataracts.

We had chosen to camp the first night at Cottonwood Campground, breaking the cross-canyon trip into three days, instead of two. I thought this would be wise due to the heat and the heavy weight we carried.

Ahead, we began to catch glimpses of the cottonwoods, a trademark symbol in desert climates for the presence of water. The giant trees shade the campsites and give life to the rocky hillside.

The next morning we rose before dawn. I was

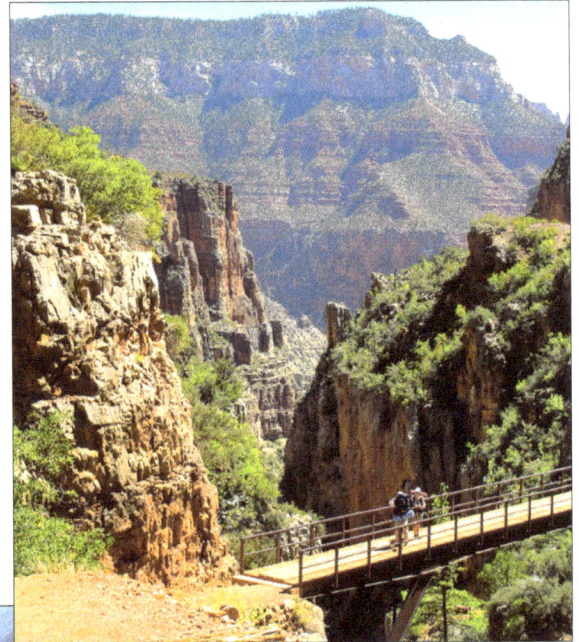

*North Rim Bridge
& Cottonwood
Campground*

delighted to find that all the training had paid off as my muscles complied with the demand to shoulder the pack once again and move out along the trail that ran creekside.

Within a mile, we came to a marsh, the last thing I expected in a desert climate. The route lay through thick oozing mud, created by water from a hillslope spring. I silently thanked the Park Service for the sturdy bridge that lifted us above the marsh.

The North Kaibab trail travels through the Box, a narrow canyon with sheer rock walls rising overhead. We were relieved to pass through the Box in the morning

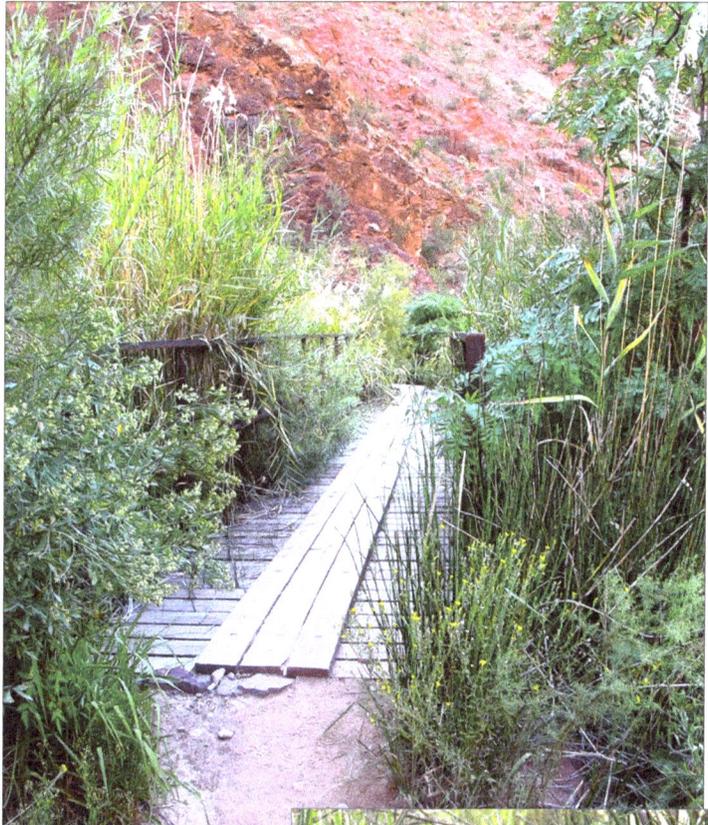

The Marsh

hours and emerge just steps away from Phantom Ranch, the only site of habitation in the 277-mile length of the canyon. A group of men cheerfully offered to share the weight from their 40-pound packs as we entered the small store and slurped down ice-cold lemonade.

Now we faced a dilemma. We had a permit

to camp at the Indian Gardens campground half way up the south rim wall. It was mid-afternoon and the temperatures were climbing. Did we rest during the heat of the day and take advantage of icy Bright Angel Creek or did we start the six-mile climb to the campground?

One woman chose to depart, thinking if she stopped that her muscles would stiffen and she would find it much more difficult to climb the canyon wall. I understood that reasoning but I also knew my poor tolerance to the heat that radiated off the rock walls.

To this day, I remain very humbled by the generosity of the four women who chose to stay with me, to rest in the shade even as their muscles cooled. We are selfish at heart and sometimes we get a small eyeful on how our selfishness effects others. I found a lesson here as I began to see my own selfishness in calling the other women to wait when they may

The Box

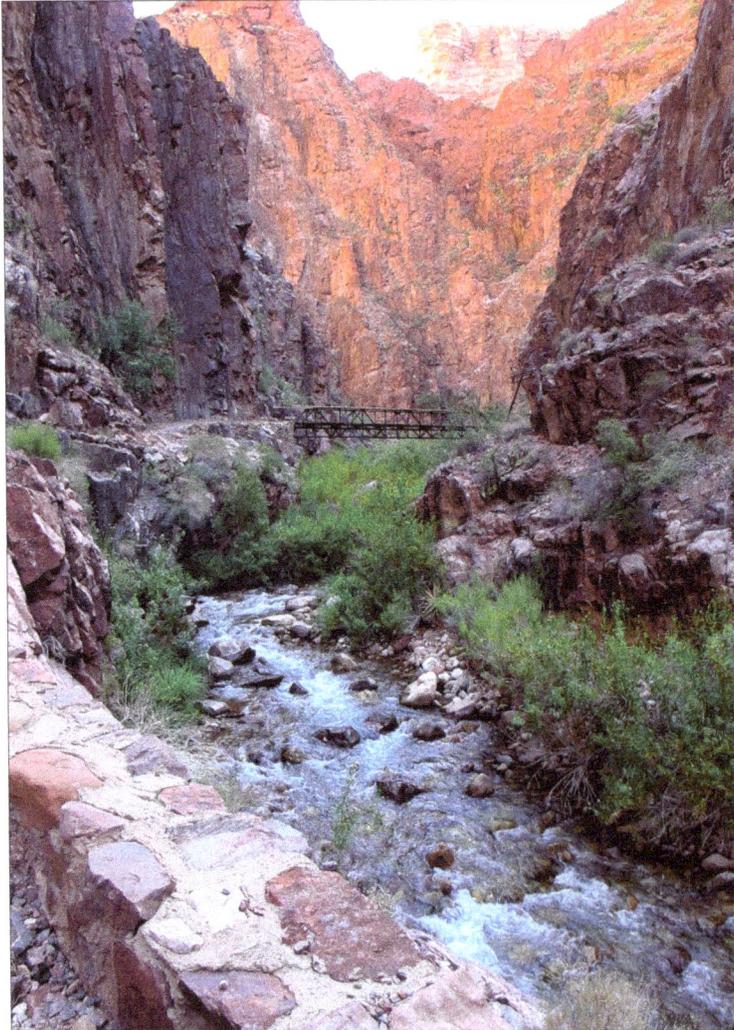

We are mortal!
Finding the balance
in caring for
others and caring
for ourselves
requires thoughtful
observation
and wisdom.

Entering Phantom Ranch.
One of my hiking partners is adamant
that the market at Phantom offers the
best lemonade in the entire world.

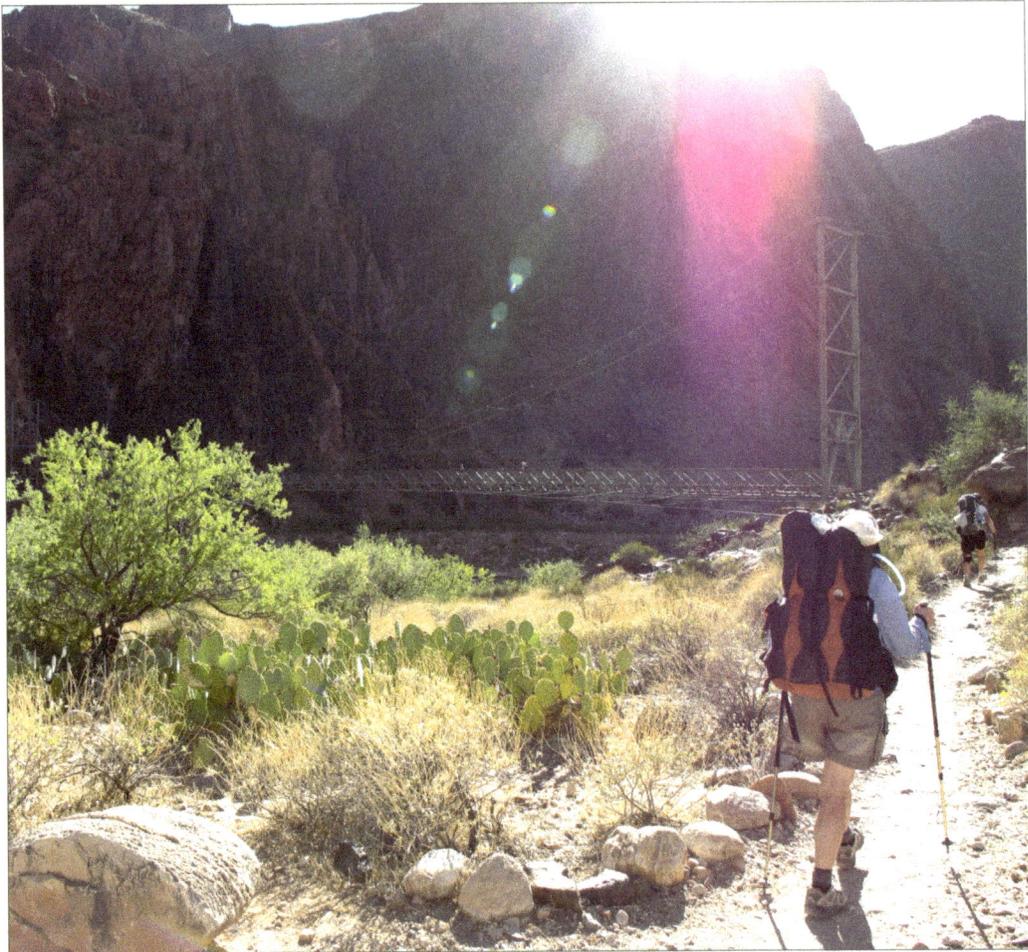

have preferred to push on!

In my desire to protect myself from injury and exhaustion, did I cause others harm?

Fibromyalgia can place us in a very self-centered position where we show little regard for other people's needs. Their gen- erosity shone when I chose to protect myself. We still need to think of others even when we are struggling to deal with our pain and fatigue. Looking back, I should have encour- aged them to move forward.

Two hours crept by and it was time to fill

our water bottles, to pull on the packs and start walking.

When the Civilian Conservation Crews built the trails into the Grand Canyon, they wrestled heavy equipment and hand tools along the rocky cliffs. A spotter would watch the canyon walls as the crews worked. If the wall began to separate and slide, he would call a warning to the crew of men, hopefully giving them time to jump clear of the slide.

Hundreds of people cross the two bridges over the narrow span of the Colorado River. These bridges are monuments to the men who suffered hardship in the dangerous work. Gazing overhead at the wires supporting the bridge I strode across the wooden boards. Below my feet the swirling current of the brown water of the river slid by on its passage to Mexico.

Across the bridge, the trail follows the river. Glancing up at the rock wall, I hoped it remained secure. Mostly I fussed at the deep sand underfoot as I struggled to take each step, weighed down by my pack. Walking through deep sand is difficult.

Pipe Creek grants an opening to a passage up the canyon wall along a series of switchbacks known as the Devil's Corkscrew.

I grumble at tedious switchbacks though they do make the climb up a canyon wall easier. I groaned as I stepped over another erosion barrier. Too much! Couldn't the trail be flat? I know erosion control is important but a three inch-high barrier every few feet?

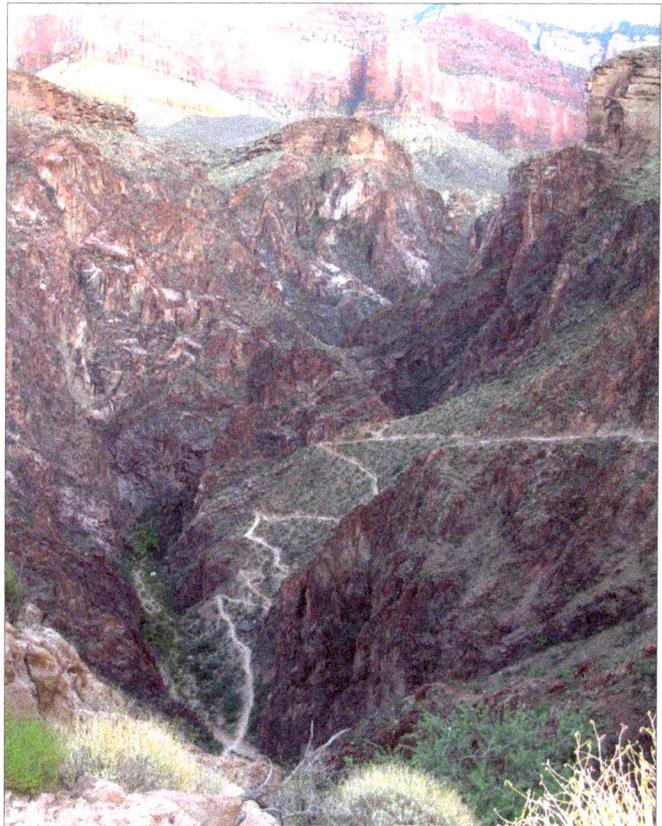

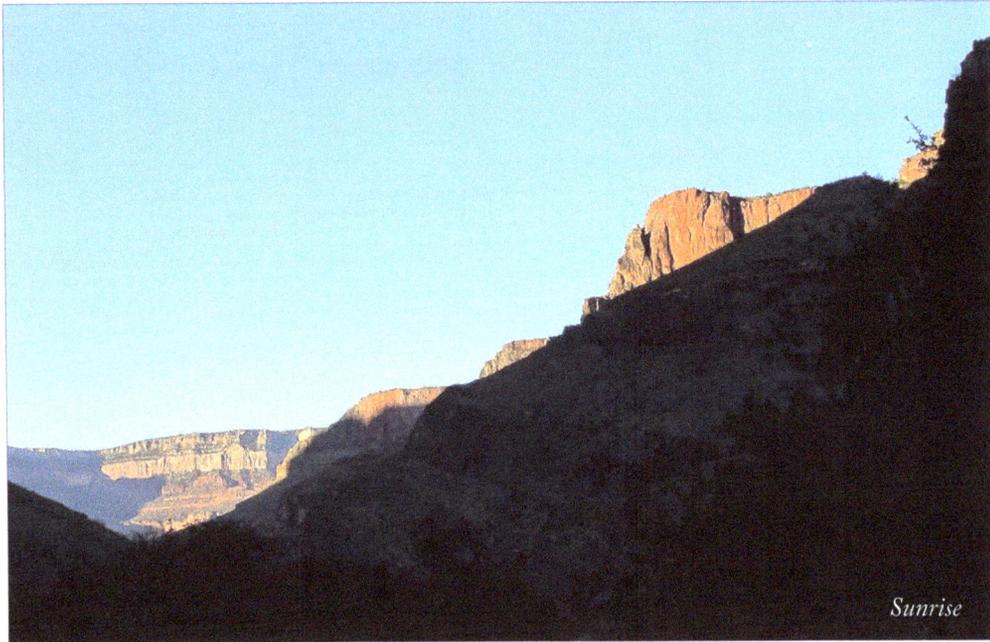
Sunrise

A quiet voice behind me echoed, "You can do this. Just keep going. It will get better."

This was the voice of a friend, one who encourages when the going is tough. Four of the women had disappeared up the trail, saying it hurt to walk at the pace I was moving. Under the weight of the pack with the weariness of eleven miles behind us, my steps were slow.

Did the group choose one person to stay with me or did this one friend just hang back, knowing that I would struggle through the Devil's Corkscrew? No, she knew this section would be a struggle and chose to slow her steps and encourage me.

The Gift of Encouragement

When we are discouraged, when we are struggling with anything in life, encouragement is a great gift. We think we can stand on our own two feet but one strong dose of pain and fatigue lands us on our backside. As we plunge into a major flare-up, we wonder

what all our effort has accomplished. Are we making any progress at all?

Looking up the cliff at the trail as it wound through the switchbacks, I forgot about the training I had done. All I could focus on was the weight on the back and the effort it took to lift my foot over the next barrier.

Walking with another person through a difficult time allows us to lean on the other when we are struggling, both mentally and physically. My friend did not let me slide into self-pity even as she kept up an encouraging thread of conversation. She helped me keep a good perspective while adding empathy to the struggle.

Peering through the North rim tunnel.

Confronting the Demons

Before I describe the final challenge of this hike, I want to consider a stumbling block that holds us back.

The friend that remained behind with me was carrying the heaviest pack in our group. She had prepared for every challenge she could imagine, and as a result, her bag bulged with items we might need. As we turned to climb the Devil's Corkscrew, I had not missed the fact that she had taken the tent from my partner and added it to her pack, the heaviest pack in the group.

I began to struggle not with just a difficult climb but with anger as well. Anger is one of the demons that afflicts any physical effort, a little voice that distracts us from maintaining an attitude that lends grace to our steps.

Knowing my friend had offered to take the tent, and that my hiking partner had been all too willing to hand her the extra weight, did not sit well with my sense of what was fair. In that moment I wished for a body that had not betrayed me with the weakness of fibromyal-gia. It was probably just as well that I could not take the tent as I would have carried the burden of injustice long after the hike ended.

How often do we continue to focus on the wrong we believe others have done or the mistakes we have made long after the moment has passed? The aggravation and anger clouds our minds and takes a toll on the muscles in our back, neck and shoulders. We become so focused on the wrong we perceive that we fail to watch where we are stepping. We stumble through life.

No, I didn't stumble over the soil retention barriers, but my anger began to steal the joy of what we were doing. The anger began to tighten the muscles in my shoulders and jaw, leaving me impatient with the others in my group.

Earlier I had mentioned the need to learn to focus on what was important. I could not go back and undo the decision made between these two women. I could choose to release the anger and not allow it to destroy me. But

I needed help to do that. This is why we say that counseling might be helpful. All of us deal with anger and perceived injustice. We have memories from our past that require attention to achieve a good mental balance.

It was not enough to admit I was angry, I needed a way to resolve that anger. There had been incidents in my past that I had excused as part of what life required. I had buried the emotional impact of these incidents to keep from facing the truth about the decisions made beyond my control. Such damage to our psyche does not stay buried. Eventually, the wounds surface, sometimes at inconvenient moments.

As we reached the campground, the other women came forward, lifting our packs and placing them on the rails high above the ground where rodents could not invade our bags of food. I allowed them to take my pack even as I tried to ignore my anger.

Doctors tell us that stress plays a huge role in fibromyalgia. In struggling with the physical symptoms of fibromyalgia, we tend to forget the toll of the emotional baggage we carry. When the wounds begin to sur-face they may emerge in a wrestling match between our soul and the physical elements of our body: the muscles, the nervous sytem and the functions of our various organs. This conflict lends power to fibromyalgia.

Years earlier a doctor had insisted that I needed psychological counseling and I firmly rejected such an idea. Now, I was fifty-five years of age and the door to to what I had hidden began to creak open.

We certainly can shove the door to the past closed and hope no one notices the pain seeping around the edges. Or we can choose to confront the lies we have told ourselves and shed light on the dark areas that trouble our minds. We have a choice. Counseling can help us to focus on what is important.

As I began to honestly face some of the things that had been done to me as a child, I found the anger diminish. I could not change what had happened but I could face it honestly and name what had been wrong. Then, I began to forgive.

Today, I know that like anyone I resent being treated unfairly, being cast aside in favor of another person. I want to see justice prevail.

I still struggled with a`sense of unfairness but at least I recognize where it is coming from and work to address it correctly rather than letting the tension build along my muscles.

While we cannot change the wrong done in the past, when we identify the action and consequences in our lives, the wrong has less power over us.

Alleviating Stress

Confronting past issues can relieve one source of stress in our lives that works against us. Unfortunately, stress is a huge factor in our culture today. Doctors tell us that stress has a detrimental effect on our physical well-being. Some doctors would even like to credit the stress of everyday living as the cause of fibromyalgia.

I understand that there are people who have no problem with stress. I suspect that this is not quite honest. I've noticed even the most laid back, easy-going person have moments when they are handed a situation that is beyond them. I hope that is some comfort those who struggle with stress.

My husband likes to remind me of a doc-tor who told him why dogs don't get ulcers. When something bad happens or the dog doesn't understand why he is mistreated, he takes a nap.

If I took a nap every time stress entered my life, I would get nothing done. However, I can choose how I react to stress. This is a life-long pursuit!

If the problem lies in being overwhelmed by all that we have to do, we need to consider our priorities and eliminate what we can until life becomes easier to manage. The choices can be hard and require us to weigh our values and what is important in the long run.

Stress and anger are the twin demons that create havoc in our lives. We do not have to hand over our physical or mental well-being to these cruel taskmasters.

As I climbed the switchbacks up the South Rim of the canyon, I thought about the anger that had settled on me the day before. I did not want to be angry with my friend and I resolved that I had to make some changes within.

The next morning we folded the tent to-gether, pulled on our packs and set off across the plateau toward the final climb. A magnif-

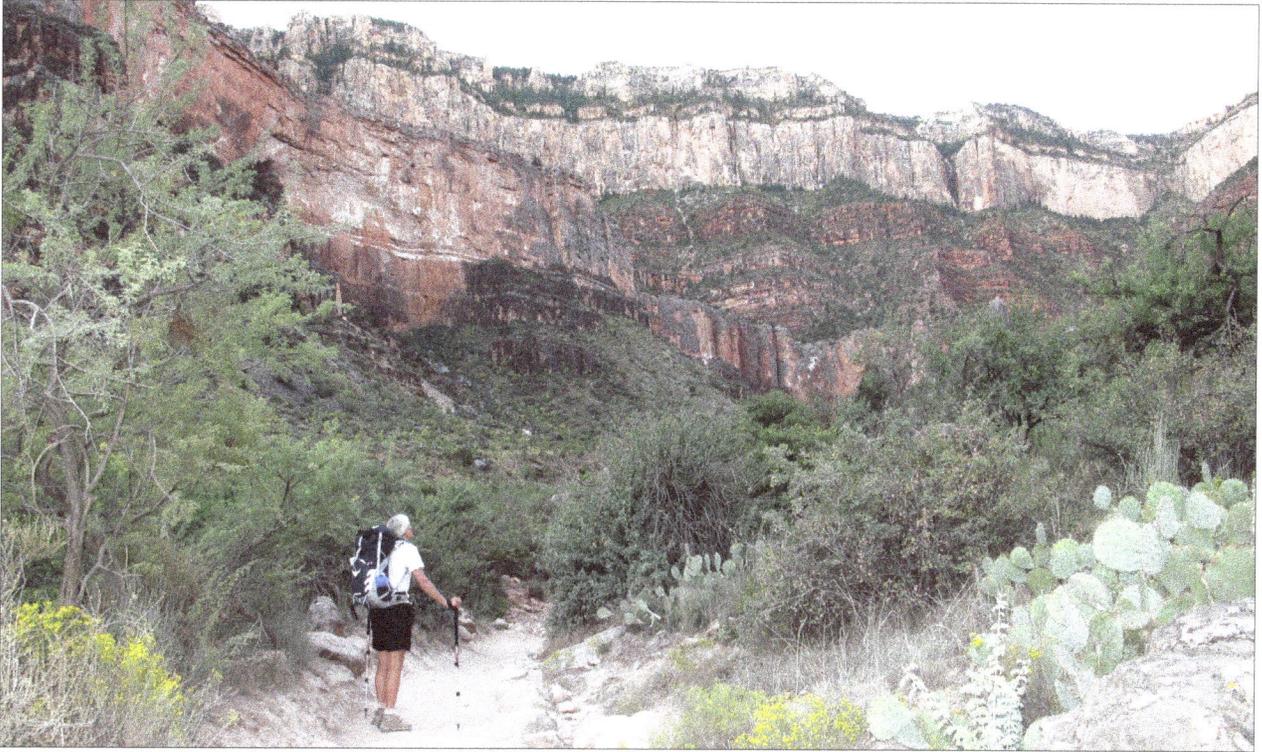

Approaching the South Rim

icent buck with a full rack of antlers stood grazing along the trail. He briefly lifted his head to examine us as we stole by.

One of my partner stopped to gaze up at the rock cliffs overhead with dawn breaking somewhere beyond the canyon walls.

"Absolutely magnificent," she breathed.

"I love the early mornings in the Grand Canyon."

The sun was rising and we hurried forward, watching the landscape lighten around us. The Canyon had one more challenge left for me, hidden in the folds of the rock overhead.

Passing the Goal Post

As described earlier, we had divided the twenty-four miles across the canyon into three segments. The first day we had dropped down the North Rim for seven miles to the first campground. The second day, we had crossed the canyon and climbed the first six miles up the south rim, a distance of thirteen miles. Only four miles remained along a steady ascent to the South Rim. At the top, hikers suddenly find themselves merging with crowds of tourists in the Grand Canyon Village.

Indian Gardens, four miles below the rim, is accessible as a day hike. The closer a hiker moves to the South Rim, the more people fill the trail. Many of them look as if they descended a little too far below the rim with questionable footware and conditioning.

They take little notice of those with back packs laboring up the switchbacks. Some do not step aside, failing to grant right-of-way to those struggling uphill.

My hiking partner stayed with me until the trail began to seriously climb. When I stopped for a break, other hikers with heavy backpacks passed me. In turn, as they took breaks, I passed them. This was repeated until out of familiarity we exchanged a few comments on the view beyond the edge of the trail or offered a word of encouragement.

There are two wayside stops between the South Rim and Indian Gardens, one at mile and a half, the other at three miles below the south rim's trailhead. Each of these has a restroom and water faucet. I quietly cheered as I passed the three mile mark, feeling strong and capable of hiking to the rim. Three miles remained until I would find my husband and celebrate the accomplishment.

I began to eagerly look for the next way-stop. At the base of a ridge I glanced up and noted a cloud of dust back lit by the rising sun. There is only one thing in the Canyon that creates that kind of dust cloud. Mule train coming!

I hurried onward, hoping to find a good spot to move off the trail as the mules passed me. The mules have the right-of-way. They do not move aside for anyone

or anything. The riders gaze with open curiosity at the hikers but few greetings are exchanged. We each have a different perspective on the dusty trail. For their part, the riders are hanging on for dear life as the mules plunge down the rocky slope.

As I turned to move on, a stabbing pain knifed through the left side of my lower back. I gasped and staggered to the inside of the trail. Dropping my pack onto a sandstone ledge, I sat down. I was fairly certain that a nerve in my back had just gone haywire.

Be wise, I thought. You can't afford to make the wrong decision. I decided to rest and eat after taking some pain medication.

As we planned this trip, I encouraged the others to go ahead if they did not wish to wait for me. I was fully aware that I could be injured and left alone with no help. Now, it seemed that this had happened.

A ground squirrel hurried over, eager to share any leftover provisions. I noted

the progress of the river-bound mule train. Hikers continued to stream past. I sat and waited for the medication to become effective.

Finally, I stood and gingerly pulled on my pack. The pain seemed to have subsided but it was still there. If the pain became unbearable, I would have to stop and ask for help. I worked to keep my mind on something other than the possibility of permanent injury.

A half mile from the rim, I looked up to see my husband striding down the trail, a big grin splitting his face. My shoulders slumped in relief. He shouldered my pack and turned back toward the rim, quickly leaving me in his dust. I stared after him, astonished that he would leave me behind!

I kept moving forward. With my pack gone I no longer feared permanent injury. Other hikers coming down the trail noted my smile, my easy manner.

"How far have you come today?"

I would turn and gesture toward the opposite rim.

"From over there," I would tell them.

I had hiked the canyon! The voice taunting me had disappeared. In its place was a melody without words, swooping, swinging on the breeze around me. A celebration of accomplishment in the face of a daunting challenge.

When faced with a difficult challenge, our thoughts are consumed with the struggle to get through each day. In living with fibromyalgia, having a significant goal can serve a useful purpose.

The goal gives us motivation to get up each day, the motivation to work toward a reward. Just as with hiking the Grand Canyon, we set small goals along our route. Each time we reach a goal we are entitled to celebrate.

As I reached the Canyon rim, two smiling

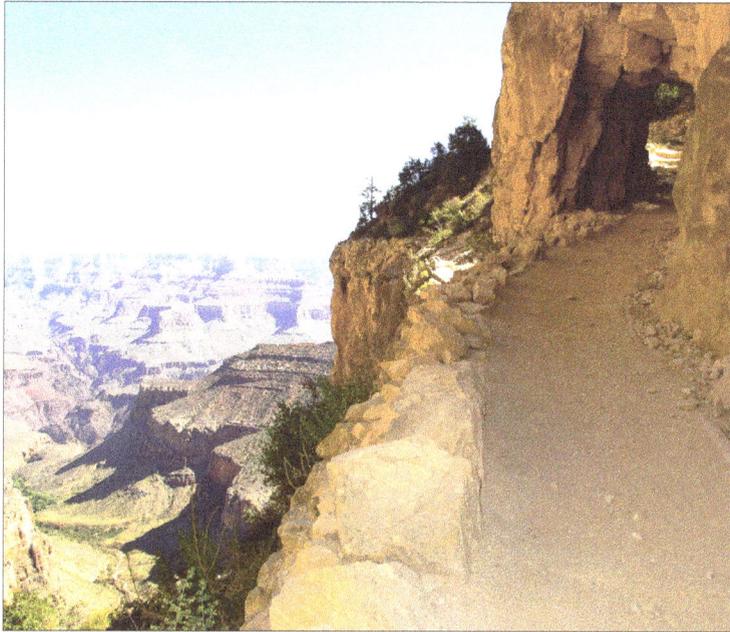

The last tunnel ascending the south rim.

faces greeted me, my husband and the friend who had urged me forward through the Devil's Cork-screw. I handed my camera to my husband even as I limped toward a iron railing.

"Take our photo!" I insisted.

"Really?" he asked. I never want some-one to point a camera in my direction, prefer-ring to be the one behind the camera.

"Yes!" I gritted my teeth, trying to ignore the pain.

Smiling, he snapped the photo of my friend and I leaning against the iron railing that once served as a hitching post for the mule train.

"Something to eat, maybe an ice cream cone?" he asked

I shook my head and reached for the pain medication.

"Just take me home."

The celebration would have to wait as I drifted off to sleep in the embrace of acet-aminophen and ibeprofen.

A damaged nerve will heal one eighth of an inch each month. The pain along the left side of my back remained for several months and that nerve easily becomes inflamed today. But . . .

I hiked the Grand Canyon! With fibromy-algia. I did not settle for pain and defeat.

Speaking of Nourishment

While our focus in living with fibromyalgia may be on pain managment and fatigue, nutrition may play an important role as well.

One day a client entered my office and in the conversation that followed he revealed that his wife struggled with fibromyalgia. He was quite certain that a dose of vitamins would fix her problems. Vitamins were all she needed!

He was interested in my belief that it is possible to live without a prescription for a drug such as Lyrica. I began to explain what was involved.

Repeatedly he asked me to just confirm that all she needed was vitamins. He had no interest in the therapuetic value of exercise or proper rest. Just vitamens.

Finally, I brought the conversation to an end, feeling badly for his wife. I'm sure he went back to her and said I agreed with him that all she needed was vitamins!

Diet

When we think of devastating illness like diabetes, diet plays such an important role in the managment of that illness. The diet preferences for fibromyalgia are not as obvious. There is no special diet for those who live with fibromyalgia other than to make healthy choices in what we consume. However, we might recognize that some foods are useful and other destructive for those who live with FMS.

When I first began to think about what I eat, like so many Americans, I was in love with bread products and anything sweet. I wasn't so sure about meat. Being a vegetarian sounded appealing. My beverage of choice was black tea, sweetened.

* DASH - Dietary Approaches to Stop Hypertension.

Then my blood pressure went up and I began to follow the DASH diet.* I found I had more energy and felt better. The DASH diet emphasizes less salt, which meant reading labels as we have a lot of salt in processed foods. DASH emphasizes fruits, vegetables, nuts and grains with lean cuts of meat and fish. I found that most of our soups and sauces had to be made from scratch to reduce the salt.

When my husband decided to cut out bread and potatoes, I noticed that over the next year he lost nearly 20 pounds. I searched for alternatives to potatoes by delving into some of our refined grains.

Due to this experience I began to ask what foods were most to my benefit and what failed to contribute to my well-being.

I spent some time talking with a doctor who emphasizes wellness. She attributed much of the pain and fatigue of fibromyalgia to inflammation. We might ask what foods contribute to inflammation in our diet and research seems to point to products that has been highly refined. Eating grains and vegetables in their natural form seems to protect our bodies again inflammation and promote bowel health.

Also important is seeking a balance between the quantities of protein and healthy (complex) carbohydrates we consume.

What foods are best for those with fibromyalgia?

We need protein to build muscle while the carbohydrates give our bodies fuel as energy. Without the protein, our muscles will be deprived of nutrients and are not repaired from the damage of every day activities.

To say a carbohydrate is complex means that the body takes longer to break the substance down into glucose, giving us energy over a longer stretch of time.

Complex Carbohydrates:
buckwheat
barley
oats
lentils
quinoa
potatoes
sweet potatoes
beans
peas
potatoes

Simple Carboydrate:
Any form of sugar. Refined & processed carbohydrates

* DASH is an acronym for Dietary Approaches to Stop Hypertension

Simple carbohydrates are processed quickly, giving a quick boost of energy and then nothing for the long term.

The diet I began to develop has elements of the popular Keto and Mediterranean diets. With the Keto diet, we emphasize a low amount carbohydrates and a moderate level of fat. Not just any fat but those that are good for you. Certainly an interesting idea but after losing weight, many people on the Keto diet find that they need to reintroduce complex carbohydrates into their diets to maintain their weight and provide more energy.

The Mediterranean diet emphasizes complex carboydrates along with a lot of fish as found along the shores of the Mediterrnean Sea. If you're a fan of fish, you might consider this a good diet. Otherwise, poultry becomes important in providing protein.

If you're a vegetarian, then obtaining the necessary protein comes from a careful balance of grains and dairy.

Many people have begun to struggle with celiac disease or at least intolerance to either gluten or wheat. Unfortunately, our society in an effort to make our grains more palatable has refined flour to the pith of a kernal of wheat without the vital nutrients and fiber found in the hull. This is also true of white rice. The difference with the Mediterranean diet is the emphasis on ancient grains rather than the refined grains and flours we find on our shelves today.

Some dieticians believe that we would see less wheat intolerance if we returned to using whole grains rather than refined flour. Certainly, we might see less inflammation if we are eating whole products rather than refined.

Lately, renewed interested in the ancient grains has produced recipes and cooking techniques that allow us to enjoy whole grains again. Spend a little time with the internet investigating these grains and you'll find new ideas for what you consume. The ancient grains do take a little more time to prepare but careful planning

The Ancient Grains Include:

Buckwheat
Oats, unrefined
Quinoa
Millet
Wild Rice
Amaranth
Farro

(Emmer, Einkorn and Spelt are all different forms of Farro.)

Why Sugar Promotes Inflammation in Fibromyalgia

One of my biggest pitfalls comes with an addiction to sugar in any form. Like many others, I crave it!

Unfortunately, studies have shown that refined sugar has a corrosive effect on our bodies, particularly on the muscles. For those struggling with fibromyalgia, keeping our muscles fit is a real challenge. Giving up sugar helps us in that battle. I confess my efforts in this area fade in and out. I may do well for a few weeks and then stumble.

In a discussion on wellness, I learned more about the effect of the amount of sugar in our diet.

Our bodies transform sugar into glucose. The pancreas then produces insulin to control the distribution of glucose to the cells in our body. If our pancreas is working well, it can handle an excess of sugar. However, over time, if our body is required to repeatedly produce insulin to control excessive glucose, the cells in our bodies become overladen with glucose molecules, creating an inbalance with the protein molecules.

Instead of an even distribution of glucose to protein, we end up with cells called free radicals that damage the membranes of other cells and leave us open to inflammation, illness and fatigue. As our bodies produce insulin, our hormones, including testosterone and estrogen respond. If our hormones become imbalanced our thyroid may deviate in its role. This all begins to sound like anarchy is taking place in the role of these different organs that are so important to good health.

Along with the food groups, we should reconsider using sugar and caffeine. If our consumption of sugar is producing too much glucose and causing inflammation in our bodies, we should reduce its intake. A number of alternatives have come on the market. Some of them are nothing more than a less refined form of sugar. Read the labels!

can make this fairly easy.

Another concern is with dairy products. Research seems to indicate that milk, cheese and yogurt are unlikely to produce inflammation for those who do not have a lactose intolerance. However, many believe that milk products can increase the mucus throughout our bodies and they choose to limit dairy products in their diets. There has been some discussion over whether certain blood types can tolerate dairy products better than others.

For me, dairy products are an important source of protein and calcium. Each individual will need to determine whether they can tolerate milk products. If you are thinking of eliminating dairy products, do so. After a couple of weeks, try adding one product at a time, starting with yogurt. Watch for any sign of inflammation occurs.

In discussing a healthy diet, what we can eat? What leaves us with a sense that we are healthy with energy to complete each day? Here is what I've concluded:

Meat poultry, fish and a small
amount of red meat,
1-2 servings a day
Grains when possible, unrefined,
2-3 servings a day.
Vegetables 2-4 servings a day
Fruit 3-4 servings a day
Nuts and Seeds 1-2 servings a day
Dairy 1-2 servings a day, depending
on the individual!

A few more details: For servings of grain, think about grain as a hot cereal in the morning. Ezekial bread is a good source of sprouted grain.

Potatoes, classified as a complex carbohydrate, became a huge part of our diet as many of the early immigrants came from countries where potatoes were a staple. Recently, mashed cauliflower or turnips have become popular, replacing potatoes on the dinner table. For those who are struggling with their weight, these two root crops might be helpful.

Increasing the fruits and vegetables helps to bring more fiber and vitamins into our

bodies. The sweetness of the fruit brings joy to our diets. Studies have shown that berries hold high anti-inflammary elements. I love berries and so this is something I indulge. The Mayo Clinic suggests that reducing refined sugar and adding more fruit and vegetables to one's diet can actually improve cognitive thinking.

Nuts have protein but they also have fiber. One of the complaints about FMS is gastro-intestinal irritation. Along with walking, fiber may be an important part of helping to regulate a healthy intestinal tract.

Fiber is not something we add quickly. Better to ease into a high fiber diet and give our body a chance to adjust or we will experience painful bloating and gas along with loose bowels. Each person has to determine whether nuts and seeds belong in their diet.

While dairy can be constipating, adding yogurt to our diet helps regulate our stomach and digestive tract. When these food groups are combined they can often achieve a healthy balance that gives us energy to burn.

Caffeine has an effect on our nervous sytem. If the nervous system is already chal-lenged, what are we doing with energy drinks and multiple cups of coffee? I'm going to suggest one cup of coffee in the morning. Make it good! As an avid tea drinker, I face the same challenge with black tea and try to drink herbal tea later in the day as a substitute.

One more suggestion: As a veteran of the DASH diet, may I suggest reducing your salt consumption? We've developed a fondness for salt, believing that it brings out the flavor in food. As I began reading labels, I learned that we are consuming teaspoons after teaspoon of salt - daily. If you're a world class athlete or working outside in high temperatures, you may need that salt. Otherwise, you're mistreating your body and this again may be contributing to the inflammation we experience.

With all this in mind, take a moment to consider how you shop at the grocery store. The next time you walk into the store, take a look at the layout. What is on the perimeter? What fills the middle aisles?

Fruit and veggies, meat and dairy all take their places along the outer walls of a super-market while the refined foods are placed on shelves in the middle aisles. It does take more

time to prepare unprocessed food rather than reaching for pre-processed selections. However, good choices will pay off in a healthier diet.

Supplements

Along with a healthy diet, there are some supplements that may prove helpful. As I mentioned above, a good vitamin regimen is helpful but it is not the whole answer to living with fibromyalgia. Supplements can target specific problems but here are two warnings:

1) Supplements affect the chemistry of our bodies and must be treated as carefully as we do medication. Taking more than is necessary may actually harm our bodies. A blood test may be helpful in determining whether we actually need what we are considering.

2) Homeopathic remedies effect us at a slower pace than prescription and over-the-counter medication. If we do not see a difference within a week or so, a longer period of time may be necessary.

For many, melatonin, a chemical naturally produced by the body, when taken orally may require up to two months to help us form a healthy sleep pattern.

Add only one supplement at a time to judge effectiveness and cross reactions with other supplements or drugs you are taking.

Here are some ideas about supplements that may be helpful. I have gleaned the information from different sources.

Magnesium is really important to our bodies for several reasons. This supplement may help reduce inflammation within our bodies and regulate our bowels while improving nerve function. It helps to restore muscle and tissue, gives us energy and helps us think clearly. All of these are issues with fibromyalgia. The differences are subtle. As noted earlier it is very important not to take too much magnesium - side effects include diarrhea and nausea, lethargy and muscle weakness. Too much magnesium can effect the heart, blood pressure, kidneys and lungs.

Along with magnesium, *malic acid* can help with inflammation. This is a substance found in apples and is sometime paired with magnesium in tablet form.

Vitamin D is used to treat chronic pain and has been useful for some fibromyalgia patients. Overall, vitamin D is important

in maintaining good health. As our culture spends less time outdoors we are not receiving the vitamin D that we used to obtain with exposure to sunlight. This is apparent as our cycle of colds and illness increase each winter. Doctors now recommend adults add vitamen D to our diet two to three days a week as a means to fight illness.

We think of *Calcium* for healthy bones but for older people this supplement is also important for muscle function and nerve transmission. Nephrologists, doctors who treat the kidneys, recommend a calcium supplement no higher than 500 milligrams as excess calcium can cause kidney stones!

Tumeric in capsule form can often help with inflammation. Some try the herb as a paste rubbed into the skin but that is more likely to leave your skin yellow with very little reduction in pain. Many stores stock tumeric root. Grate and add about one tablespoon of the root to salads and stews. Too much tumeric can create intestinal discomfort.

We've already talked about *Melatonin* as an aid in establishing and maintaining sleep patterns. **Chamomile** mixed with peppermint tea has elements that calm the mind and help to induce sleep. Some people also find valerian helps calm over active minds.

Restful sleep is helpful in combatting depression. There are natural herbs that help with depression. Depression has a number of causes and can be very difficult to treat successfully. I recommend consulting with a naturopath for assistance rather than experimenting with friends' suggestions!

Omega 3, found in cold water fish and dark leafy greens, is good for the circulatory system and helps with inflammation in the muscles and joints. Omega 3 does not mix well with melatonin when taken together in the evening.

We do need to remember that supplements are not a substitute to eating a healthy diet and obtaining the nutrients we need from whole foods.

Body, Mind and Soul

I've spent a good part of this discussion on our physical bodies but this is not the sum total of who we are. The relationship between mental stress leading to physical breakdown is poorly understood. Sometimes when our bodies are unwell without an obvious cause, we need to look at what troubles us mentally.

Often we have pushed aside a conflict or problem we feel powerless to address. While we move on physically, the mind is all too aware of this issue. Even as we work to forget, our subconscious state is not at rest. In time, the conflict begins to exhibit its presence through physical ailments.

In recent years, medical practitioners have begun to ask questions about our emotional and mental state when confronted with a complex diagnosis like fibromyalgia. At one time this was a common approach but science has stolen the soul from the practice of medicine. In talking with those with FMS, I often find that issues from the past, along with stress and the fatigue of simply living in our fast-paced culture have left us with an emotional-deficit.

Pull out the assessment you took at the beginning of our discussion. Think again about the questions I asked.

What causes stress in your life?
What percentage of your day do you feel as
 if you are under stress?
Do you feel overwhelmed at times?
If so, how do you handle stress?
What unresolved issues from the past still
 haunt the corners of your mind?
What issues remain up front and center?

We can become so focused on resolving the pain and fatigue that has taken over our lives that we ignore the mental and emotional drain that comes with daily living.

I hate it when someone tells me that I have too much stress in my life and I need to reduce that stress! Stress is part of living. We don't get away from it. Whether it is a child whining

for something beyond our level of tolerance or a boss that demands more than we can produce, stress is a part of life.

How do we handle stress? There are thousands of books written on how to handle stress and I do not intend to replicate any program for stress management in this manuscript. However, by acknowledging that we live with stress, we can begin to search for ways to place our focus on what is causing stress in our lives.

This may mean that we seek counseling. Or we may have to choose to change our priorities, eliminating some of the activities from our lives.

One of the best prescriptions for FMS does not come in the form of a pill.

Laughter!

When we laugh out of amusement, chemicals surge through our brain, leaving us feeling good. Our lungs open to good air, our abdominal muscles clench and then relax. Our minds are given a release from tension.

I've learned that being grateful is important in how we face each day. When we think of all the things we are thankful for, even the smallest, gratitude is a firm wedge against self-pity or anger.

Exercise is important for releasing the tension that builds during the day. It helps to release tight muscles and improve our breathing.

Meditation, a good nap and living an intentional life all help. Due to my faith, I believe that God has a purpose in all that comes into my life and I have to choose whether I will trust him for what is happening or whether I will give in to worry and speculation.

We can choose to become very intentional about how we live and how we think, directing our thoughts in positive directions. You may find it helpful to write down how you wish to handle stress and worry. Review your ideas weekly and revise your ideas as needed.

Along with examining the tension that comes with everyday activities, we also should consider our past. As a child, I was left in a boarding school. At six years of age, I did not understand the reasoning behind this but to question my parents' decision would have been disloyal.

As I reached my fifth decade, I began to acknowledge that anger was a real issue for me and I struggled to recognize the cause of that anger. The emotions that I had learned to stifle at such a young age began to tumble out.

Our minds are complex and often we find it is easier to stifle or to hide the pain of things that have happened to us in the past rather than face the disapproval of those involved in what has happened.

Part of successfully working with fibromyalgia is healing our minds and emotions. When we confront past conflicts and honestly face how these conflicts have effected us, we can choose to step onto the path to healing. We cannot change the past but we can release the tension of past memories.

One of the methods being touted today is Eye-Movement Desensitization and Reprocessing (EMDR). Quite a mouthful but this technique is being used successfully with those who have suffered high degrees of trauma. The technique is intended to move painful memories from one part of the brain where they are on a replay circuit to another part of the brain where we can remember the incident without the grief and pain associated with those memories.

As we review the past, we may find painful issues where we have recall something that must be resolved.

Do you need to go back and apologize for something you've done? Do you wish the person who has wronged you would apologize?

There is little to gain by digging up old conflicts unless we can apologize for our role and set things right. If we cannot do so, then a counselor may find a way to help us resolve the conflict.

When we release painful emotions from the past, it may feel as if a weight has been lifted from our shoulders. Suddenly, we are free to move, to interact with each other, to simply breathe. We are free to heal.

Soulful

Along with the mental and emotional elements of our being, I wish to address the soul or spirit that lives within each of us. This is not a topic that most medical providers would even consider addressing. This is puzzling when you consider that we are defined as having a body, a mind and a spirit.

My final challenge to you in learning to to live with fibromyalgia is to examine your relationship with God, even if you are an atheist. I believe the health of one's soul or spirit is a vital element in discussing a person's health.

My mother seemed to think that God looked over my shoulder periodically to remind me of how short I fell in his expectations. When I was a child, that formed the basis of my relationship with God.

Today, I see God as a loving Father who wants the best for me. After all, he came to earth and was born as a baby, growing into a man who would give his life on my behalf. He came so that we could know Him for the loving God that wants the best for us. When we understand this, the struggle with fibromyalgia takes on a whole new perspective.

Earlier, I asked, "What is your image of God?"

The first commandment that God gave to Moses as the leader of the Jewish people in the Old Testament was, "I am the Lord, your God . . . You shall have no other gods before me."

Regardless of your religious beliefs, let me ask: What is your god? What is the most important thing in your life?

To me this immortal, all present, all powerful spirit identified as God takes precedence over everything else. If I don't give him the time, the energy, the respect that he deserves, my body and mind will begin to fray and disintegrate.

For those who believe in God, who at least accept the concept of a God, the idea that we cannot neglect our spiritual health is beyond negotiation.

He wants every bit of us, body, mind and soul. So what is your view of God?

When we begin to see God as one who loves us and wants the best for us, we can release the pain, the fatigue and even the depression over to him. We can offer our tears and frustration as a gift to him that he will use to bring about his best.

This takes time, a whole lifetime.

He wants the best for us. A deliberate study of pain and inadequacy in the Bible clearly show us that God uses what seems bad to make us more like Him.

So take the time, to sit and listen, to talk with God about fibromyalgia and what he intends you to learn out of this weakness.

> **What? Shall we receive good at the hand of God and not receive evil?**
>
> **Job 2:10 KJV**

> **"(God) said to me, 'My grace is sufficient for you, for my power is made perfect in weakness.' Therefore, I will boast (take comfort) all the more gladly about my weakness so that Christ's power may rest on me."**
>
> **II Corinthians 12:9-11 NIV**

Love in the Depth of Pain

I have long admired Joni Eareckson Tada, a woman who was left a quadriplegic after a diving accident. She has gone on to live a vital, influential, dynamic life. In one of her more recent books, she talks of her wheel chair as a place of healing. For most of us, a wheelchair looks like a method of transportation for someone unable to fully use their body as God intended. I had never considered a wheelchair a place of healing.

Joni does not limit God. Nor does she chase every hope of healing. I don't want to say that she has given up on the idea that she could be healed to walk again but she understands that all of us are damaged by sin. That damage may be expressed in mental disorders or physical symptoms. Whatever the cause, we are all damaged. We are all in need of healing.

She talks of how God has used her chair to bring her to an understanding of her need of healing from selfishness, lack of kindness, lack of trust, fear and any number of other characteristics that have developed due to the sin in her life. God is using her wheelchair to bring these things to the surface so that he can heal her, making her more like Him.

When I was first diagnosed with fibromyalgia, I came to believe that God did not wish to heal me of this condition. I could not explain why and some people took this as a lack of faith in God. As I think of Joni's words, I echo her sentiment. God has used the fibromyalgia to make me aware that I must depend on Him. I need healing from all the wrong that I harbor in my life.

If I had been able to sail through life without the limitations of fibromyalgia, I might never have learned to listen to God. I would not have slowed down to rest and hear His voice quietly calling me.

Many friends see the pain and fatigue that haunts the corners of my life. If God can use fibromyalgia to heal me of the deep hurts, the wounds, the bad decisions, the sin I harbor, then I am thankful for fibromyalgia. Through the pain and the fatigue, I see a God who loves me infinitely more that I can understand. And I long to be open to Him.

I find that there is love in the depth of pain.

Some of the references explored when forming this mauscript:

http://www.fmperplex.com/2013/02/26/what-is-fibromyalgia-ii

https://www.painscience.com/articles/fibromyalgia.php

http://www.webmd.com

Mayo Clinic Guide to Fibromyalgia

Interviews with physical therapists and doctors specializing in wellness

www.ingramcontent.com/pod-product-compliance
Lightning Source LLC
Chambersburg PA
CBHW040832040426
42336CB00034B/3434